# BASEBALL
## IN
# BATON ROUGE

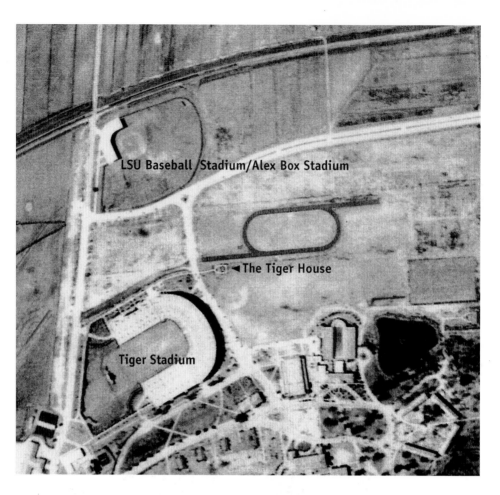

LSU Baseball Stadium/Alex Box Stadium

◄ The Tiger House

Tiger Stadium

LAND OF THE GIANTS. This 1941 aerial view portrays Louisiana State University prior to America's entry into World War II. Tiger Stadium, completed in 1924, looks like an embryonic version of the massive facility we recognize today. The baseball field, a Works Progress Administration (WPA) project, was built between 1937 and 1938 and christened Governor Richard W. Leche Stadium. The governor resigned in 1939, and the facility became known as LSU Stadium until 1943. For the first two years of its existence, this was the spring headquarters of the New York Giants. As home to the LSU Tigers, this ballpark remains, both in spirit and accomplishment, a land of giants. (Courtesy of Department of Public Works, Engineering Division, City of Baton Rouge.)

COVER BACKGROUND: This photograph, taken in August 1948, shows boys from Baton Rouge at Bogan's Pasture. (Courtesy of Whip Bertrand.)

FRONT COVER: The first official LSU intercollegiate baseball game was played against Tulane in Baton Rouge on May 13, 1893. (Courtesy of Andrew D. Lytle Collection, Mss. 893, 1254, Louisiana and Lower Mississippi Valley Collections, LSU Libraries, Baton Rouge.)

BACK COVER: An evening game in progress is pictured at Alex Box Stadium c. 2000. (Courtesy of LSU Sports Information.)

# BASEBALL
## IN
# BATON ROUGE

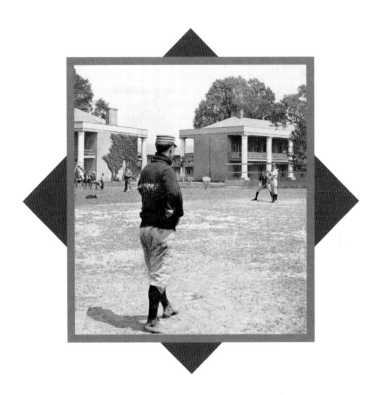

*Michael and Janice Bielawa
with a foreword by Mel Didier*

ARCADIA
PUBLISHING

Published by Arcadia Publishing
Charleston SC, Chicago IL, Portsmouth NH, San Francisco CA

Printed in the United States of America

Library of Congress Catalog Card Number: 2006923341

For all general information contact Arcadia Publishing at:
Telephone 843-853-2070
Fax 843-853-0044
E-mail sales@arcadiapublishing.com
For customer service and orders:
Toll-Free 1-888-313-2665

Visit us on the Internet at www.arcadiapublishing.com

This book is dedicated to the wonderful baseball community of
Baton Rouge. Janet, Jimmy, and Kelsey—you make every day
Mardi Gras. Whip and Willie—your words will live with us forever.

# CONTENTS

# ACKNOWLEDGMENTS

Janice and I have met so many wonderful baseball people during the two-plus years of researching this book. We wish to thank Mel Didier for preparing the foreword and sharing his baseball memories; they are worth another book. Thanks to L. J. Dupuy, Mr. Baton Rouge Baseball, and his wife, Debbie, for so many insights and introductions. Janet, Jimmy, and Kelsey, thanks for giving us a home. Thanks to the hardworking and patient research crews at LSU's libraries, Hill Memorial and Middleton. Judy Bolton, you're a genius. Tara Z. Laver, Luana Henderson, Germain Bienvenu, Mark Martin, Margaret Stephens, and Cristina Fletes are the best. Thanks to Pat Kelly and Bill Burdick at the Baseball Hall of Fame in Cooperstown. Thanks also to Asst. Prof. Clifton Theriot and Prof. J. Paul Leslie of Nicholls State University. Bill Franques of LSU Sports Information is "the Man." Stephanie Cargile of ExxonMobil is a miracle worker; thanks to Marie Brown, too. The management of the Exxon Mobil Corporation went out of their way to help. Thanks go to Willie and Gloria Spooner; Earle and Hugh Wagley; Bob and Joyce Didier; Jason and Christine Williams; Red Murff; Rogers Hornsby McKee; Coaches Skip Bertman and Roger Cador; Coach Pizz (Richard Pizzolatto); John Fetzer (and his joie de vivre); the Manuel family; Lenny Yochim; Sandra Gourrier; Louisiana State Rep. Ronnie Johns; Johnnie Allan; S. L. Montalbano; Joe Stein; the staff at the East Baton Rouge Parish Main Library and Edna Jordan Smith at Bluebonnet Regional Branch Library; Ann Boltin from the archives department at the Diocese of Baton Rouge; Whip Bertrand; D. R. Atkinson and Auburn Bryant; Mike Bertrand for sharing his dad's scrapbook; Virgie Ott with the City of Gretna; Executive Editor Linda Lightfoot and Dianne Guidry at the *Advocate*; State Library of Louisiana's Charlene Bonnette; microfilm staff at New Orleans Public Library; our St. Louis research assistant, Stephanie Nordmann; Carolyn Bennett and Kristin Gerac Coco of the Foundation for Historical Louisiana; Larry Foreman of Ouachita Parish Library; Kathy Spurlock, editor of the *Monroe News-Star*; Angela V. Proctor at Southern's John B. Cade Library; fellow Society of American Baseball Research members, especially Tim Copeland; Jan Breen of Catholic High School; Fran Franser of Istrouma High School; Chicago Historical Society's Bryan McDaniel; Bob Waltman; Kenny Kleinpeter; Steve Kleinpeter; Mary Eggart, Sacred Heart of Jesus; Tracy Rouch, *St. Louis Post-Dispatch*; Stephen Milman for sharing his antique baseball books; old friend and library director Eric Johnson at Southeastern Louisiana University's Linus A. Sims Memorial Library; Jeneane Lesko of the All-American Girls Professional Baseball League; Stephanie V. Smith; Michael Plymill; Nathaniel Mills; Lydia S. Bergeron; Charles Hartlage, DANA Corporation Media Relations; Robert D. Retort; Leatus Still; Bryan Harmon, Russell Broadbent, and Greg Vannice of the Engineering Division, Department of Public Works, City of Baton Rouge; Recreation and Park Commission for the Parish of East Baton Rouge's Marc Palmer, Earl Thomas, and Myrtle Keller-Perkins; Kim Apley and Leslie Gilbert at UPI and Regalle Asuncion at the Associated Press; Jay-Dell Mah; Steve Raguskus for proofing; Sweeney and Fisher for enthusiasm; Clay Luraschi, Topps Company; Jerry Taylor, director of operations for the National Baseball Congress, Wichita, Kansas; the staff at Kinko's on Airline Highway; and finally, special thanks from Janice and me to the most wonderful research assistant in the world—Michele Muffoletto.

# FOREWORD

There has been a history of baseball in the Baton Rouge/New Orleans area that not many people in the baseball world know about. Baton Rouge especially has been known for its great football history due to the LSU Fighting Tigers. But underneath all of this football lore lies a great history of baseball in the capital city of Louisiana.

Since before World War I, baseball has played an important part in the leisure and sporting life of Baton Rouge fans. Semipro baseball flourished in Louisiana just before, and after, World War II, especially in the southern portions of the state led by the dynamic Esso Standard Oil baseball club, who entertained all comers from the area, state, and out-of-state teams.

Underneath this "upper" level of baseball, Baton Rouge had great high school, college, American Legion, and youth baseball teams. Mike and Janice Bielawa bring the make-up, the history, and many of the players back to life. Their research has taken them to the natural roots of baseball in the Baton Rouge area. It is a complete and astounding history of the national pastime in the land of bayous, with all the names of the teams and players who took part in the great game of Baton Rouge baseball.

—Mel Didier Sr.
Phoenix, Arizona
February 2, 2006

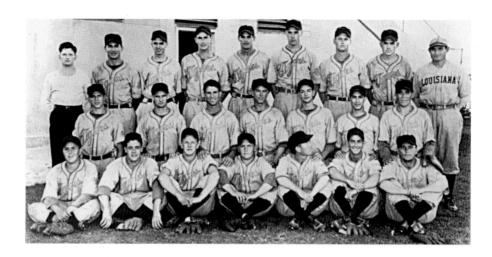

TIGER RAG. This 1939 team was the first to win a Southeastern Conference (SEC) baseball championship for LSU with an overall record of 22-6. Harry Rabenhorst, standing on the far right, is deservedly remembered for coaching LSU's basketball team; however, Rabenhorst was also head baseball coach for 27 years, from 1925 to 1942 and 1946 to 1956. LSU won the SEC again in 1946, under Rabenhorst. (Courtesy of LSU Libraries' Special Collections, Baton Rouge.)

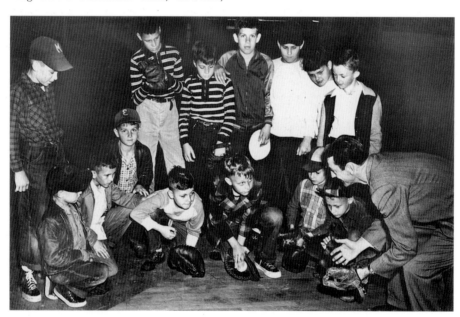

INDOOR BASEBALL. Inclement weather wasn't a damper to spirits or schooling at the Baton Rouge Kids' Baseball Clinic. Rain chased the lessons indoors in this c. 1948 photograph. The instructor, even in his civilian suit and tie, still holds an audience rapt, showing the boys how to field a grounder. Clinic cofounder Walker Cress's son, John (born in 1942), is seen kneeling on the far left. (Courtesy of John Cress and Bob Waltman.)

# INTRODUCTION

Baton Rouge has always been a baseball town. Now that might sound like heresy to the 100,000 gridiron fans that gather on Saturdays in and around Tiger Stadium, but the simple fact remains that baseball holds a magical place in the heart, mind, and culture of this city. Baseball devotee Mark Twain observed, "Baseball is the very symbol, the outward and visible expression of the drive and push and struggle of the raging, tearing, booming nineteenth century." Remove the reference to time in Mr. Twain's statement and replace it with the words "city of Baton Rouge," and one comes close to visualizing the role baseball has played in this community for over 100 years.

Why has Baton Rouge always been a baseball town? Just consider the game's impact. Although fans here love football and basketball, and these sports are certainly an economic force, baseball reflects momentous events that have visited Baton Rouge. Baseball has been played on warm afternoons when the crowd's only thought is whether a ball may be caught or fall in for a hit, but more poignantly, baseball has buoyed the town in times of fear, flood, and financial difficulties. Baseball has been a part of the events that have molded the character of this city. In turn, folks with a Baton Rouge connection have also impacted baseball on the national level. Names like Adcock, Brock, and Didier, along with a host of others included in these pages, have each carried a bit of Baton Rouge with them as they navigated the base paths of the major leagues.

Baseball in Baton Rouge has a long history. Next to horse racing, "base ball" is one of the city's earliest sports. The game came into vogue less than 100 miles downriver among New Orleans amateur leagues as early as 1859. It is not difficult to imagine a cloth-stuffed piece of leather being swatted in these parts before the War Between the States. Occupying Union troops undoubtedly played ball here during the Civil War. Eddie Vaughn, interpretive and exhibit coordinator at Magnolia Mound Plantation in Baton Rouge, explains, "The Union Army had some 5,000 troops encamped on Magnolia Mound. That number does not account for any of the other encampments in the area. The popularity of baseball among the soldiers combined with the fact that by 1864 Baton Rouge was relatively calm, the bivouacked troops would have had extensive periods of free time on their hands, I can't believe that there wasn't a game on the plantation grounds. Baseball was just too popular among the troops."

Baton Rouge baseball "matches" (the game borrowed the cricket term) continued in earnest during the Reconstruction period when amateur teams competed on local fields. Mark Carleton's book, *River Capital*, notes, "In 1867 the locals were stomped 54 to 24 in seven innings by the local occupation troops."

In addition to amateur clubs, the capital has accommodated a number of professional franchises. The first pro team to call Baton Rouge home was the 1902 Cajuns of the newly formed Cotton States League. Games were played at Battle Park. Judge George Mundinger lived across the street from the ball field and was a league umpire. Considered a baseball authority, Mundy was among the very first Louisianans to play major-league ball in 1884. Throughout the 20th century, Baton Rouge professional teams continued to be a part of summer's stage, with entries representing the Dixie League, Evangeline League, Gulf States League, All-American Association, and Southeastern League.

Baseball in Baton Rouge was temporarily silenced by plague, flood, and racial tension. But the game endured. The 1905 yellow fever epidemic devastated baseball in Baton Rouge, while the Great Flood of 1927 forced teams from other Louisiana cities to relocate here. When the Great Depression wounded minor-league ball, the powerhouse Esso team stepped up and proudly carried the sport's banner for Baton Rouge. The city is home to the LSU Tigers, one of the winningest teams in the history of the College World Series, and Southern University, one of the oldest black colleges in the country, which won a national title at the onset of the civil rights movement. Baseball will continue to be a part of the fabric of Baton Rouge. Children will play on local diamonds. Scouts will continue to look to these ballparks and universities and minor-league teams for future major leaguers.

Baton Rouge is filled with baseball stories. Important and fascinating baseball players, managers, coaches, and fans have graced this city. We are grateful to have met so many friends in baseball who have shared their memories. This book has allowed us the opportunity to speak with the 20th-century's youngest major-league winning pitcher, the gentleman who scouted and signed Nolan Ryan, the person who brought Little League to the disenfranchised, and to hear a dying man's wish to express one of the finest moments in his life—Baton Rouge winning the state All-Star game against New Orleans. In many instances, this is a book about dreams coming true. It is our hope that these stories and photographs preserve the essence of Baton Rouge's ongoing baseball heritage, a history that at times has been tragic and sad. But in all cases, baseball has inevitably embraced folks and helped people to move forward. Baseball in Baton Rouge is a transfiguring and uplifting force.

There is a reverence for life in Louisiana that undeniably appears on Baton Rouge baseball fields. Overcoming obstacles is something the people of this city have always done well. The crack of the bat, slap of the glove, and cheers rising from the stands has always been a sign of this strength. It is our dream that baseball's seasonal rhythm always beats in the heart of Baton Rouge.

Yours in baseball,
Michael and Janice Bielawa
Prairieville, Louisiana
Woodbury, Connecticut

# THE BIRTH OF
# BATON ROUGE BASEBALL

No one knows the exact date of the very first baseball game played in Baton Rouge. Perhaps the game became popularized by Union troops occupying the city. However, the sport was already avidly played in New Orleans at the beginning of the Civil War, so one can reasonably assume that a form of the game would have been available to citizens living in the antebellum capital. Baseball records and memorabilia from this time are not altogether plentiful and are indeed rare with respect to Baton Rouge.

The information that follows was collected over a period of years and provides a unique glimpse into the social history of this city. The portrait created is that of a town that embraced the game early on in amateur contests during the 1860s, directly leading to professional baseball, which arrived at the turn of the 20th century. Amateur clubs of this era were often private organizations or guilds that gathered more for fraternal camaraderie (and sometimes gentlemanly wagers) than for focusing on admission prices or concession sales. The first professional franchises and full-time paid players brought volatility to the game. Players jumped to other clubs, and teams abandoned one city or league for greener pastures (and revenues). Such is the reality of minor-league baseball. But local heroes were born and even mini-dynasties developed within these pro loops. This is the beginning of Baton Rouge's rich baseball heritage.

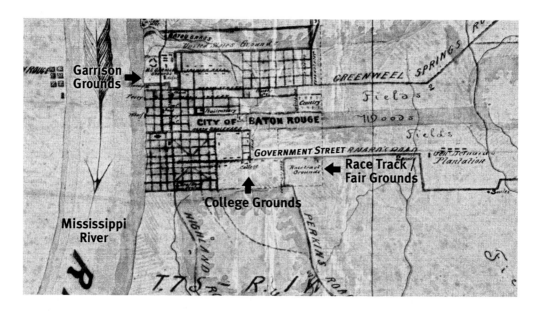

EARLY BATON ROUGE BASE BALL FIELDS. Following the Civil War, Baton Rouge was home to two amateur teams, the Redsticks and Capitolians. "Matches" were played to display skill during friendly gatherings as opposed to focusing exclusively on victory. Teams met Wednesdays and Fridays at the Garrison Grounds and on Sundays at Magruder's Collegiate Institute on Government Street, shown on this c. 1860 map. Games also took place at the horse track, the same area that hosted the Louisiana State Fair. (Courtesy of LSU Libraries' Special Collections, Baton Rouge.)

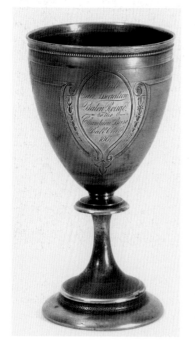

THE HOLY GRAIL OF BATON ROUGE BASEBALL. Perhaps the oldest existing relic from Baton Rouge's primeval baseball era, this cup was awarded at the 1867 Louisiana State Fair held at Baton Rouge. On December 23, the Redsticks squared off against the visiting New Orleans Southerns. The inscription reads, "La State Fair Association Baton Rouge—To The Champion Base Ball Club—1867" and, on the other side, "Won by the Southern Base Ball Club of New Orleans." The Southerns embarrassed the Redsticks, defeating them by the astounding and inglorious score of 109 to 9. (Courtesy of Robert Edward Auctions.)

BOX SCORE. Here is the published account of the November 26, 1868, game between the amateur Southern Junior Base Ball Club and the Pattersons played in Baton Rouge. Hits and at-bats are not listed. A "ballist" was measured by how his actions supported the team, not by individual accomplishments. The statistics indicate runs scored and outs made (known as "hands lost"). High scoring games were the rule rather than the exception. (Courtesy of LSU Libraries' Special Collections, Baton Rouge.)

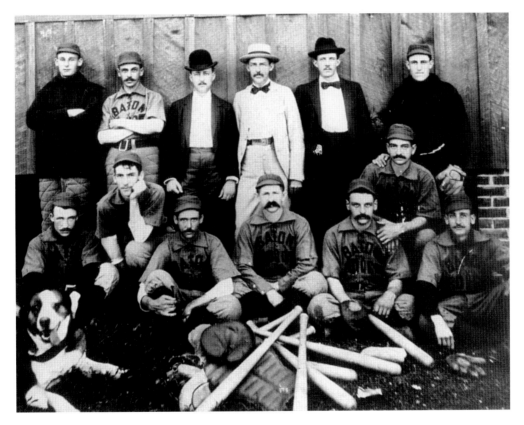

THEIR FACES CALL TO US STILL TODAY. This unidentified photograph, dating from around 1900, features contemporary equipment and fashion. Gloves do not have any webbing. The catcher's body protector on the ground may be of the inflatable variety. (Courtesy of Foundation for Historical Louisiana Photograph Collection.)

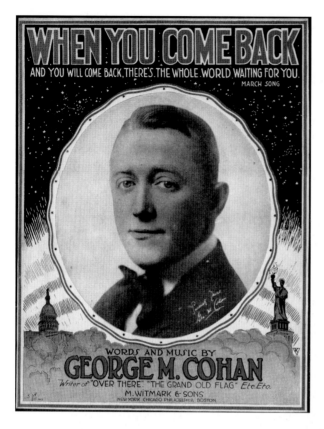

GEORGE M. COHAN'S BIGGEST HIT. Broadway's patriotic songsmith, George M. Cohan, was passionate about baseball. Cohan regularly attended major-league games in New York. He also organized ball games between casts of Broadway shows. According to Fred Grouchy, the steward at Baton Rouge's Grouchy Hotel, when Cohan's traveling play stopped in the city around the turn of the 20th century, the troupe invited Fred and his brother, Alex, to play baseball with them. (Courtesy of the Michael Bielawa Baseball Collection.)

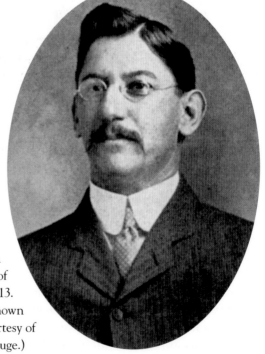

THE TALENTED MR. ROUX. Jules Roux was president of Baton Rouge's pro team from 1903 to 1905, and he shared the duties with Alex Grouchy Jr. in 1906. Roux was volunteer fire chief in 1899, second ward councilman during the early 20th century, and mayor of Baton Rouge from 1910 until his death in 1913. Jules operated a "tonsorial parlor," better known today as a barbershop, on Third Street. (Courtesy of LSU Libraries' Special Collections, Baton Rouge.)

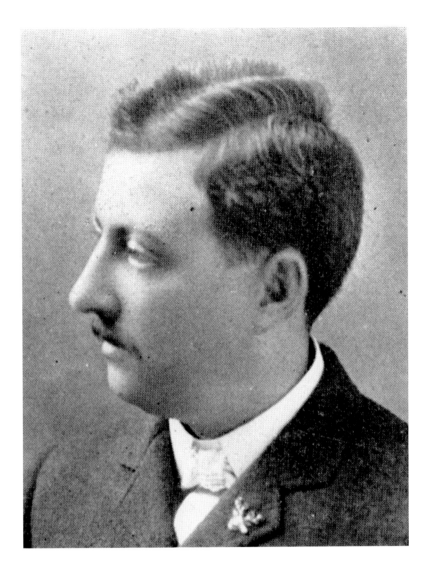

MR. ALEX. Alex Grouchy (1870–1945) and Jules Roux were instrumental in introducing professional ball to Baton Rouge in 1902. Their efforts brought a Cotton States League entry here after a team failed to secure support in Jackson, Tennessee. Grouchy and Roux's dedicated work early that year raised money and public awareness, which inevitably brought a club to the Louisiana capital. Grouchy served as the team's first president and later as secretary and treasurer. He was also a member of the board of directors for the Cotton States League. For a time, Alex was the official scorer at Battle Park. A well-respected entrepreneur, he managed his father's businesses at the Grand Capitol Hotel, which was renamed the Grouchy Hotel. In 1908, Alex and the Grouchy family took over operations a few blocks away at the Istrouma Hotel. He was a city council member, and in 1913, upon the death of his friend Jules, Alex became mayor of Baton Rouge, serving until 1922. Grouchy was affectionately known to everyone in the community as Mr. Alex. (Courtesy of LSU Libraries' Special Collections, Baton Rouge.)

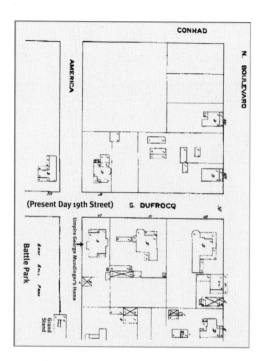

HOME OF THE COTTON STATES LEAGUE CAJUNS. Built in 1902, Battle Park was home to Baton Rouge's first professional baseball team. Four blocks south of Magnolia Cemetery, the ball yard was named in honor of the 1862 Battle of Baton Rouge. This map is one of the few remaining mementos proving the existence of the vanished stadium.

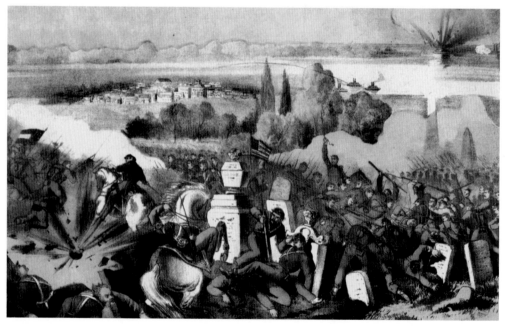

MEET THE BOYS AT THE BATTLE FRONT. On August 5, 1862, Confederate forces under Maj. Gen. John C. Breckinridge attempted to wrest the Louisiana capital from Union control. The battle occurred around two future baseball stadiums: Battle Park, located four blocks south of Magnolia Cemetery, and Stanocola Field, east of the graveyard. This Currier and Ives print dates to c. 1865.

THE BIRTH OF BATON ROUGE BASEBALL

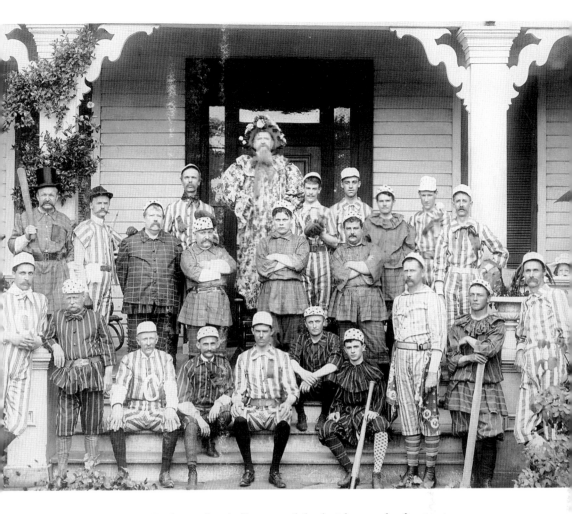

BURLESQUE BASEBALL. Burlesque baseball was a popular diversion throughout the country during the Victorian era and into the early years of the 1900s. The public paid to see politicians, doctors, and businessmen play games in outrageous costumes. The contests were usually waged as a fun way to raise money for charities. One such game took place at Battle Park in Baton Rouge on May 28, 1902. This undated photograph could actually be of these burlesque teams. Composed of members of the legislature, the five-inning contest was well attended and raised $100 for the city's two orphanages. The picture was taken at the North Boulevard home of Baton Rouge's preeminent photographer, Andrew D. Lytle. Lytle is standing on a chair in the center of the back row. (Courtesy of Andrew D. Lytle Collection, Mss. 893, 1254, Louisiana and Lower Mississippi Valley Collections, LSU Libraries, Baton Rouge.)

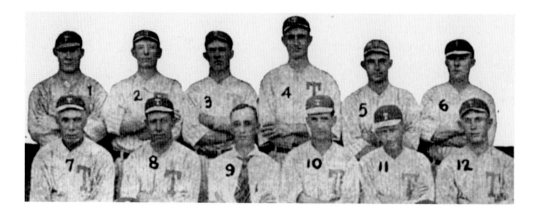

COTTON STATES LEAGUE'S FIRST BATTING CROWN. Howard Murphy (number 11) was born New Year's Day 1882 in Birmingham, Alabama. A member of the 1902 Baton Rouge Cajuns, he won the batting crown in the league's inaugural season. The outfielder batted .400. He appeared in 25 games with the 1909 St. Louis Cardinals and hit .200. Murphy is pictured here with the 1917 Tulsa Producers. Following his playing days, he worked in the gravel business in Fort Worth, Texas, where he died at the early age of 44.

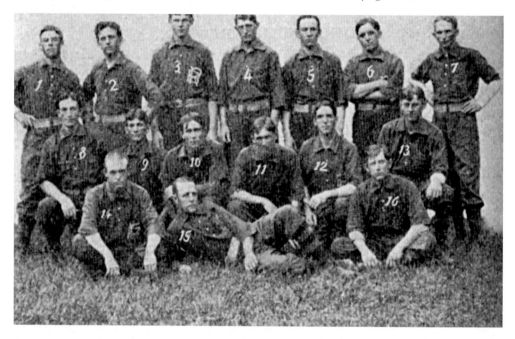

PENDER'S POUNDERS CHAMPIONS OF 1903. In 1902, the Cotton States League inaugural season, the Baton Rouge Cajuns finished in second place. The following season, the newly dubbed Red Sticks captured the pennant with a record of 74 victories and 42 defeats. Manager Robert Pender's team held the top spot in the six-team circuit from opening day until the close of the campaign, except when the Vicksburg Hillbillies took control of first for a single day. Bob Pender is seen here lying down in the front row. (Courtesy of Stephen Milman.)

THE BIRTH OF BATON ROUGE BASEBALL

THE MORE THINGS CHANGE . . . Decades before television and radio coverage, eager fans sought scores of distant games the quickest way possible: by telegraph. Inning by inning scores and game results were often relayed to newspaper offices, bars, and public halls where fans congregated for the latest news. This 1903 *Daily Advocate* newspaper advertisement promoting a local saloon offers "Base Ball Reports" coupled with the "Coldest Beer" in Baton Rouge. (Courtesy of East Baton Rouge Parish Main Library.)

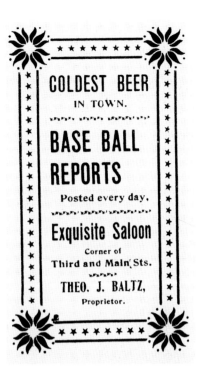

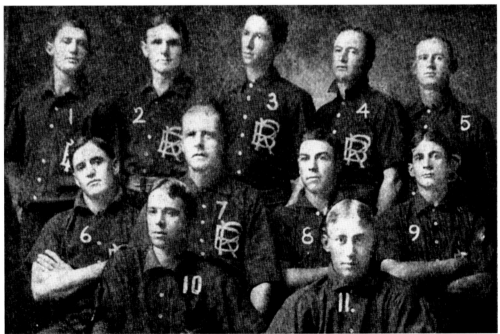

RED STICKS, 1904. Bob Pender's team slipped to fifth place, second from last, and 22 games out. The one standout, however, was Edwin Gnadinger, standing on the far left. He was the team's speedster, swiping 30 bases.

# BASEBALL!

## BENEFIT GAME
## Thursday, June 8, 1905.

## BATON ROUGE vs. HATTIESBURG

On the said date there will be a Benefit Game of
Base Ball, the proceeds of which will go to the Baton
Rouge Baseball Association.

### READ THIS.

The Board of Directors propose to give away
**Fourteen Prizes,** as follows:

| | |
|---|---|
| First Prize, First Number Drawn - | $50 00 |
| Second Prize, Second Number Drawn, | 15 00 |
| Third Prize, Third Number Drawn, - | 10 00 |
| Fourth Prize, Fourth Number Drawn, | 5 00 |
| And Ten other Prizes of $2 each for the next Ten Numbers Drawn - - - | 20 00 |
| Total Prizes, 14. Amount - - | $100 00 |

Each ticket issued is duplicated, and the duplicate
ticket will be placed in a hat, and a committee of five
to be selected from among the spectators shall be called
to supervise the drawing.
Prizes to be paid in cash, immediately after the
drawing, on presentation of the original ticket, or as

RED INK, NOT FANS, FILLS GRANDSTANDS. Low attendance at the outset of 1905 took a toll on team finances. Newspaper articles and editorials lamented the possible loss of the Cajuns. The first of several fund-raising games was scheduled at Battle Park on June 8, 1905. The price per seat was set at a steep $2. Businesses closed early so workers could attend the 4:15 p.m. game. Eventually local entrepreneurs donated the money needed to float the team. (Courtesy of LSU Libraries' Special Collections, Baton Rouge.)

HITCHED ONCE, PINCHED TWICE, TOSSED OFTEN. Cajuns manager Wilson Matthews had a roller coaster season throughout 1905. He married Maud Huyck, a girl from a prominent Baton Rouge family, in June. The Texas newspaperman also displayed a fiery temperament and was ejected from many games for arguing calls. Matthews's disposition hit a new low when, in less than two days, he was arrested twice in Vicksburg for swearing at an umpire. He is pictured here as manager of the 1907 Charleston Sea Gulls. (Courtesy of Stephen Milman.)

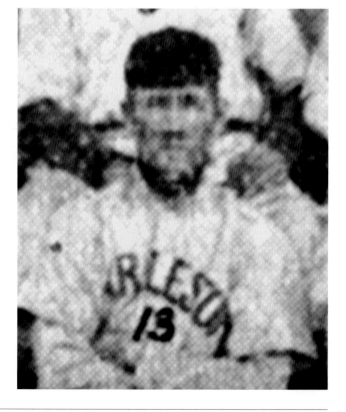

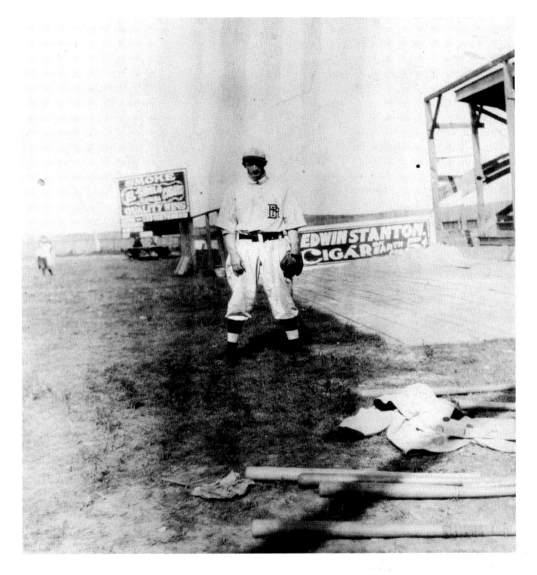

THE AMAZING MOXIE. One of the most fascinating characters in Baton Rouge's pro franchise history is Mark Garfield Manuel. He was among the first Baton Rouge professional players to make it to the majors. Manuel was born October 16, 1881, in Metropolis, Illinois. According to family lore, when Mark was a boy, he delighted in daredevil stunts and "having the 'moxie' to do adventurous things," hence the Moxie moniker. He is pictured here at Battle Park in 1905, his first season with Baton Rouge. On July 4 of that year, Moxie pitched both ends of a doubleheader against the Vicksburg Hill Climbers. Manuel won the first game but dropped the second contest in unique fashion. Despite holding Vicksburg hitless, the amazing Moxie lost by a score of 2-1 due to "a succession of [Cajun] errors and wild throws in the sixth inning." Incidentally, between pitching starts that year, ironman Manuel often patrolled the outfield. (Courtesy of the National Baseball Hall of Fame Library, Cooperstown, New York.)

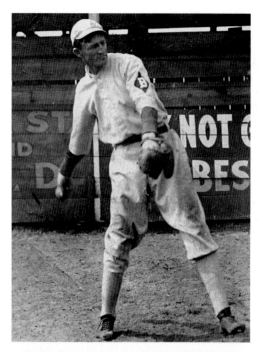

MOXIE AND VICKSBURG, AGAIN. Hurling another doubleheader for the Cajuns on July 25, 1905, Moxie defeated Vicksburg in the opening game 4-1, surrendering the Hill Climbers' only run in the first frame. Although the Cajuns lost the second game, a 15-inning marathon, by a score of 2-1, Vicksburg did not score a run against Moxie until the 12th inning. That means Moxie threw 19 consecutive, scoreless innings in a single day. Manuel is pictured here as a member of the 1910 Birmingham Barons. (Courtesy of Mark F. Manuel.)

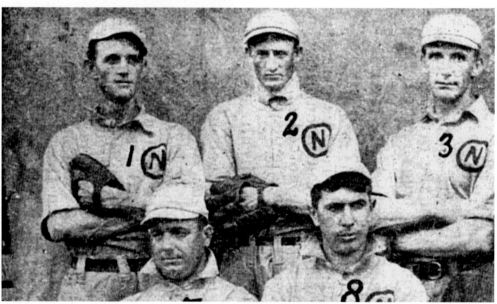

MOXIE MOVES DOWNRIVER. Moxie (number 2) was sold to New Orleans of the Southern Association when yellow fever collapsed the 1905 Cotton States League. This Class-A league continued their season by playing in cities outside the quarantine zone. Moxie is pictured here in 1905 as a member of the pennant-winning Pelicans. In yet another pitching feat, in 1907 with New Orleans, Manuel tossed 47 consecutive, scoreless innings from May 30 through June 19. (Courtesy of Stephen Milman.)

THE BIRTH OF BATON ROUGE BASEBALL

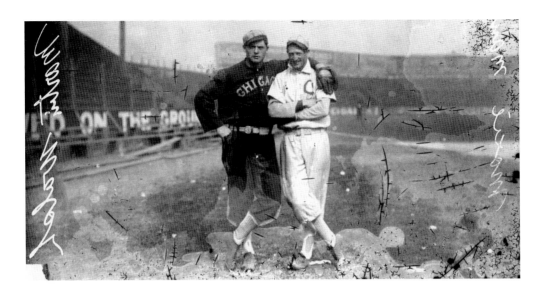

MOXIE AND BIG ED. Among the first Baton Rouge pro players to make it to the majors, Moxie is seen here with 1908 Chicago White Sox teammate Ed Walsh (left). Legend holds that Manuel hurled ambidextrously. Moxie's grandson, Mark G. Manuel, shares this story: "Once Connie Mack remarked to Rube Waddell [baseball's zaniest character], 'You better watch out for Manuel, Rube. He's ambidextrous.' Rube is said to have replied, 'You're telling me! He'd just as soon kill you as look at you!' " (Courtesy of the Chicago Historical Society.)

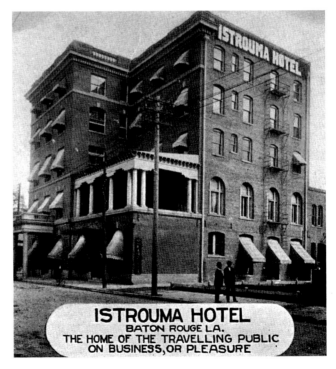

ISTROUMA HOTEL. The Istrouma opened in 1904 and was located at the corner of Third and Florida Streets. It was Baton Rouge's most luxurious hotel. At five stories, it was the city's tallest building. Players of visiting Cotton States League teams stayed here and surely relished the opportunity to savor the hotel's reputation for fine dining, not to mention the gentlemen's bar. Just $2.50 a day paid for a room with meals. (Courtesy of the Michael Bielawa Baseball Collection.)

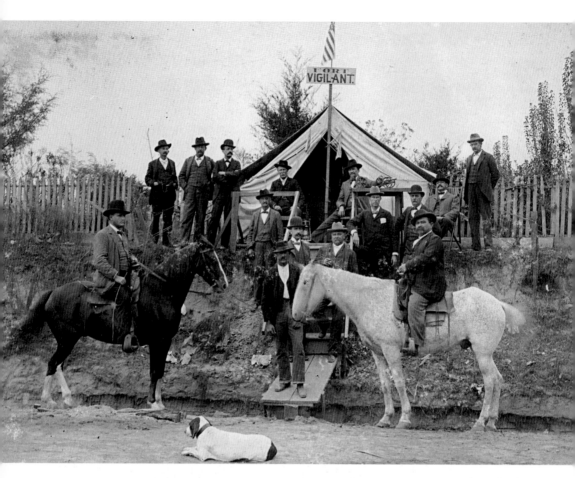

YELLOW JACK STRIKES OUT BASEBALL. During 1905, yellow fever broke out in the French Quarter. Severe illness and death accompanied the infection. Citizens did not readily believe that mosquitoes carried the disease. Quarantine took hold, and panic ensued.

As yellow fever spread northward, travelers from infected areas were not allowed to enter Baton Rouge. Quarantine stations, such as this one dating from 1897, were established to keep strangers out. Seated on the left is former Confederate general John McGrath, chairman of the board of directors of the Baton Rouge Cajuns. (Courtesy of Andrew D. Lytle Collection, Mss. 893, 1254, Louisiana and Lower Mississippi Valley Collections, LSU Libraries, Baton Rouge.)

THE BIRTH OF BATON ROUGE BASEBALL

LEAGUE PRESIDENT UNDER CRISIS. As a consequence of travel restrictions imposed on teams, coupled with the fear players and fans had of contracting yellow fever while attending ball games, Cotton States League president George Wheatley asked league directors to vote to disband the league effective July 31, 1905. (Courtesy of the Michael Bielawa Baseball Collection.)

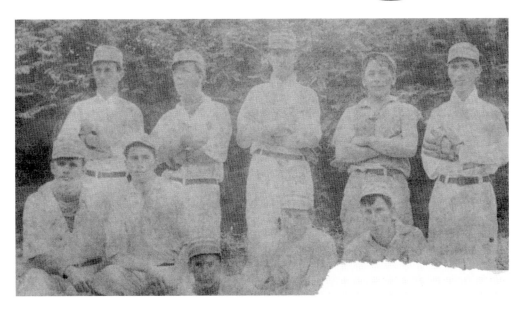

BASEBALL PROVIDES SOLACE. During the quarantine, the amateur Baton Rouge Olympias continued playing local nines, such as the Reddys and the Powells. This photograph of the Olympia club, c. 1905, features, from left to right, (first row) second baseman J. B. Heroman, first baseman L. C. Heroman, outfielder S. V. Arbour, catcher Charles Fourrier, and pitcher Julian Fourrier; (second row) outfielder Bob Lambert, shortstop Bill W. Swart, outfielder and pitcher Ogden Middleton, third baseman Frank Sanchez, and outfielder Eugene Cazedessus. (Courtesy of ExxonMobil.)

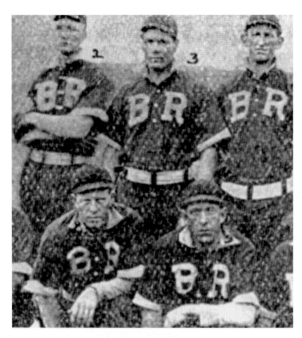

CAJUN MCCAY. Bernie McCay (kneeling, right) managed the Baton Rouge Cajuns to fifth place when professional baseball returned in 1906. He had one of the top batting averages in the league and pitched a no-hitter. Financial problems doomed the team. It would be 23 years before Baton Rouge was again represented in a professional league. The 1906 campaign ended with Mobile capturing the pennant. The Alabama club repeated the feat in 1907 under a new manager—Bernie McCay.

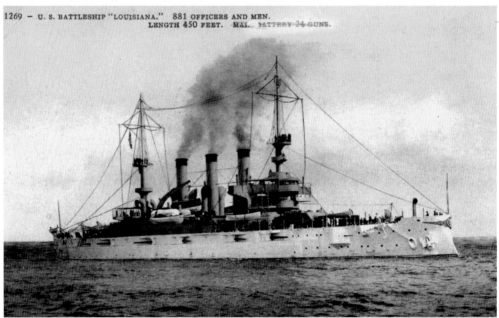

LOUISIANA'S 16,000-TON NAMESAKE. Named in honor of the Pelican State, the battleship USS *Louisiana* was built by the Newport News Ship Building and Drydock Company in Newport News, Virginia, and launched in August 1904. The ship was commissioned in June 1906. Whenever American ships made a port of call, the crew's baseball team took advantage of dry ground and played local clubs or crews of other U.S. naval ships. (Courtesy of the Michael Bielawa Baseball Collection.)

THE BIRTH OF BATON ROUGE BASEBALL

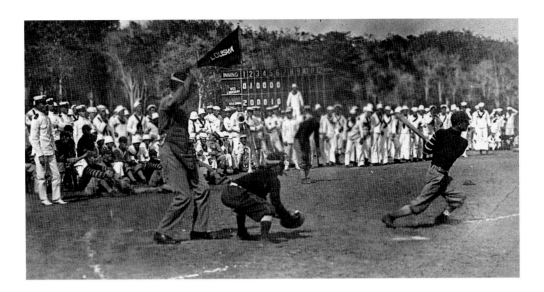

BIG STICK STICKMEN. From 1907 to 1909, the USS *Louisiana* circumnavigated the globe with other American battleships as part of Pres. Teddy Roosevelt's "Big Stick" diplomacy. The Louisiana's baseball team entertained foreign nationals as well as U.S. Navy personnel in Cuba, New Zealand, China, and Mexico. This rare action shot taken *c.* 1909 shows a sailor from the Louisiana taking his cuts. Note the musical band assembled below the "Louisiana" pennant. (Courtesy of the Michael Bielawa Baseball Collection.)

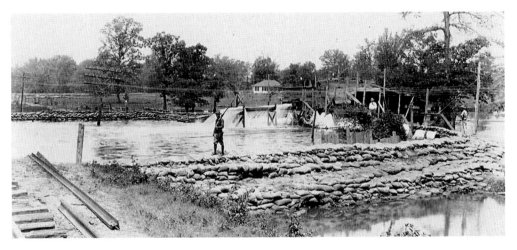

THE GREAT FLOOD OF 1927. Prior to Hurricane Katrina, the levee breaks of 1927 were the most destructive flood in American history. Rains that had swollen the Mississippi River in 1926 were augmented by torrential storms that buffeted the Midwest and South throughout the spring of 1927. As a result, the boiling Mississippi River broke through the levee system from Cairo, Illinois, down to New Orleans, flooding 27,000 square miles and displacing over 600,000 people. This photograph depicts the flood in Monroe, Louisiana. (Courtesy of Ouachita Parish Public Library, Special Collections Archives.)

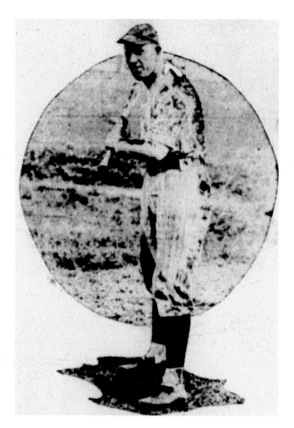

BASEBALL SEEKS HIGHER GROUND. The 1927 flood compelled Cotton States League teams to relocate because cities in the circuit were inaccessible. Pro ball temporarily returned to Baton Rouge in May 1927 with the Alexandria Reds. Then from May 29 to June 5, 1927, manager Eddie Palmer, shown here, moved his Monroe Drillers to the capital. Games were played at Standard Park. (Courtesy of the *Monroe News-Star.*)

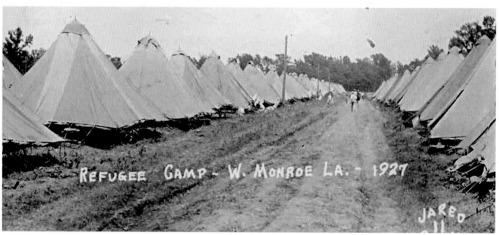

REFUGEE CAMP BASEBALL. In 2005, Louisiana flood evacuees were housed in trailers. In 1927, tent cities were established for refugees. This West Monroe camp organized a boys baseball team that challenged nines from neighboring refugee camps. The *Monroe News-Star* called on the local populace to donate uniforms and equipment so children living in the camp could "pass away the time until they [were] once more able to return to their homes with their parents." (Courtesy of Ouachita Parish Public Library, Special Collections Archives.)

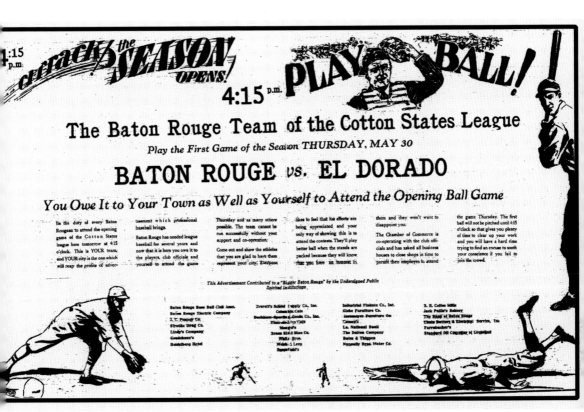

RETURN OF THE COTTON STATES LEAGUE. After lengthy negotiations, the Class D Hattiesburg Pinetoppers left Mississippi roughly a month into the 1929 season and moved to Baton Rouge. The capital officially reentered the Cotton States League on May 30 with a game against the El Dorado Lions. Standard Oil allowed the city's new pro club, dubbed the Essos, to play home games at Standard Park. The grandstand was destroyed by fire on February 22, 1929, and construction was rushed to erect temporary bleachers by the first game. On opening day, eager fans hurried to fill a portion of the incomplete grandstand, ignoring the warnings of workers. Just before the first pitch, the stands collapsed. Luckily no one was injured. (Courtesy of Capital City Press, *Baton Rouge Advocate*.)

HIGHLANDERS ACE. At the end of June 1929, a contest was held to rename Baton Rouge's team. Florida Street resident S. J. Lacy won with his entry, "Highlanders." Claude "Mus" Freeman was the ace of the 1929 staff. He got his nickname as a little boy when his brother Ed gave him marbles and told the novice not to "play for keeps." Claude was itching to play and implored his sibling, "[Aww] Mus' I, Ed?" (Courtesy of Capital City Press, *Baton Rouge Advocate*.)

UNDER A MONARCH MOON. On Thursday, May 8, 1930, a tug of an electric switch changed Louisiana baseball forever. Baton Rouge played their first night game under artificial lights. The contest pitted the Highlanders against the Alexandria Reds in Shreveport. Baton Rouge won 10-7. The lights and generators were the property of the Kansas City Monarchs of the Negro Leagues. The Monarchs rented out their portable system to offset their travel expenses. Legend persists that Baton Rouge played under electric lights years earlier. (Courtesy of the National Baseball Hall of Fame Library, Cooperstown, New York.)

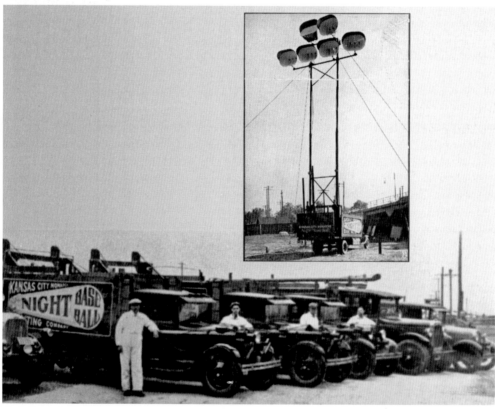

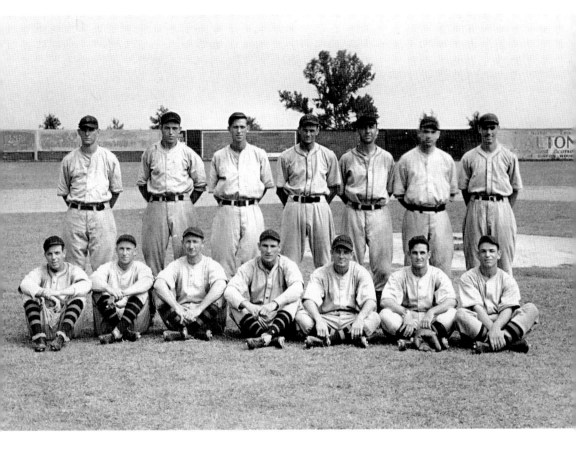

DEALING WITH DEPRESSION. The Great Depression wreaked havoc with minor leagues across the country. Many clubs failed. To bolster chances for survival, a new league was culled from the territory of the Cotton States League, East Texas League, and Texas Association. In March 1933, the Class-C Dixie League was born. The Baton Rouge Solons, managed by Josh Billings (seated third from left), won the first half of the season with a record of 41-21. The second half was a close race; Shreveport ended on top, while the Solons finished just a game out in third place. During postseason play, Baton Rouge took the all-Louisiana series four games to two. Here are the 1933 champion Solons. They led the league in team batting with a .299 average. The speedy club took the top spot in triples (85) as well as stolen bases (149). Pitcher Eugene McClung, seated in the center, won 20 games and owned the best ERA (2.34) in the Dixie League that year. Fred Gourrier stands on the far left. The Solons would leave the capital for good on June 11, 1934, to become the Clarksdale (Mississippi) Ginners. (Courtesy of the National Baseball Hall of Fame Library, Cooperstown, New York.)

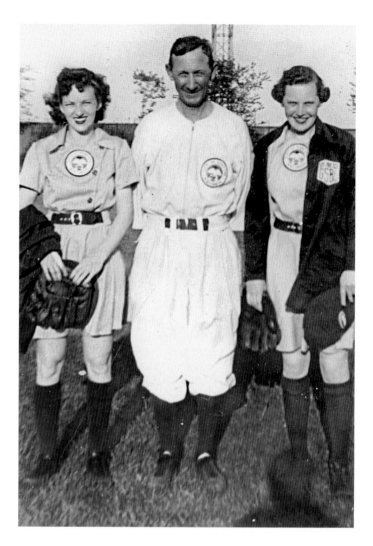

JOSH BILLINGS: IN A LEAGUE OF HIS OWN. John A. "Josh" Billings (1891–1981) played in the majors with the Cleveland Naps, Cleveland Indians, and St. Louis Browns from 1913 to 1923. Before coming to Baton Rouge, he was a 38-year-old All-Star catcher with Vicksburg. Billings is the only Baton Rouge manager in the 20th century to pilot the city's pro team to consecutive championships. He accomplished this feat in 1932, with the Senators of the Cotton States League, and in 1933 as president, manager, and catcher of the Dixie League's Baton Rouge Salons. The league was expanded and split into the East and West Dixie Leagues in 1934. Early that season, on June 11, Josh transplanted the struggling Baton Rouge club to Clarksdale. The capital would not have another pro team for 12 years. In 1943, Josh Billings became the first manager of the Kenosha Comets of the newly formed All-American Girls Professional Baseball League (AAGPBL). Josh and the Comets' Mary Lou Lester (left) and Ann Harnett are pictured here. Harnett was the first player signed by the AAGPBL. She helped design, and was the first to model, the players' uniform. (Courtesy of the National Baseball Hall of Fame Library, Cooperstown, New York.)

# REALM OF
# BROWNIES AND GIANTS

Long before Florida and Arizona's Grapefruit and Cactus Leagues institutionalized spring training, major-league teams encamped in towns across every Southeastern state. Locales from Virginia to Texas (and California, too) were home to facilities throughout the first half of the 20th century. Louisiana cities included Alexandria, Lake Charles, Monroe, New Orleans, and Shreveport.

In 1903, Baton Rouge headquartered a spring camp for the St. Louis Browns. Baton Rouge was chosen by the Brownies for several reasons. Warm weather, LSU's athletic facilities, and accessibility to rail made Baton Rouge a tempting choice. The new pro baseball stadium made the capital's selection even sweeter. However, torrential rains and low gate receipts doomed a repeat visit. It would be 35 years before another major-league club flew its flag over the city during March.

In 1934, Sen. Huey Long approached New York Giants manager Bill Terry and proposed the Gotham team conduct spring training in Louisiana. The April 3, 1934, *New York Times* reported Senator Long extolled "the virtues and climate of Baton Rouge and environments as a training base to Memphis Bill."

Four years later, Terry and Louisiana governor Richard W. Leche announced the world champion Giants had abandoned Havana and chosen Baton Rouge as their new spring headquarters. A $10,000 retainer, LSU's new baseball grounds, and the university's indoor sports coliseum (a haven during inclement weather) sealed the choice. Some 3,000 fans saw LSU's Leche Stadium christened on March 12, 1938, with a spring training game between the Giants and the Philadelphia Phillies.

ST. LOUIS BROWNS AT BATTLE PARK. Baton Rouge hosted the 1903 spring training camp for the St. Louis Browns. The team had just joined the American League the previous year. The new professional ball field at Battle Park, athletic facilities at LSU, and the fact that the city was situated on a rail line contributed to the Browns' decision to select Baton Rouge as their pre-season headquarters. This Andrew D. Lytle photograph, taken at Battle Park in March 1903, features, from left to right, (first row) Jack Powell, Tom Donahue, Joe Sugden, Bill Friel, manager Jimmy McAleer, Willie Sudhoff, John Anderson, and future members of the Baseball Hall of Fame Bobby Wallace and Jesse Burkett; (second row) Bill "Wee Willie" Reidy, Barry McCormick, Mike Kahoe, Emmett "Snags" Heidrick, team captain Dick "Brains" Padden, Ed Siever, and Charlie "Eagle Eye" Hemphill. This photograph appeared in the March 24, 1903, *St. Louis Daily Globe-Democrat*.

REALM OF BROWNIES AND GIANTS

THE CRAB WHO WAS A SPIDER. Hall of Famer Jesse Burkett was a member of the National League (NL) Cleveland Spiders, where he batted .409 in 1895 and .410 in 1896. Burkett played with the NL St. Louis Perfectos (Cardinals) from 1899 to 1901 and the Browns from 1902 to 1904. As part of his regimen during spring training, Burkett, nicknamed "the Crab" for his nasty on-field disposition, ran five miles a day around the downtown LSU campus. (Courtesy of the National Baseball Hall of Fame Library, Cooperstown, New York.)

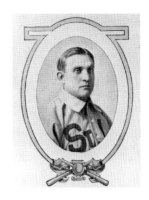

## HOW TRAINING AFFECTS MEMBERS OF THE BROWN'S TEAM

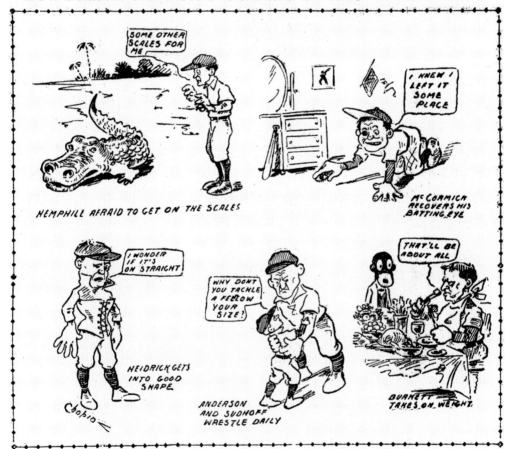

CARICATURE OF THE TIMES. This cartoon appeared in the sports section of the March 13, 1903, *St. Louis Post-Dispatch*. Hemphill and Heidrick are worried about their winter weight gain while Burkett contends with adding to his slim physique. Of more historical importance, the cartoon serves as a reminder how tolerant society was toward vulgar prejudices. (Reprinted with permission by the *St. Louis Post-Dispatch*, 2005.)

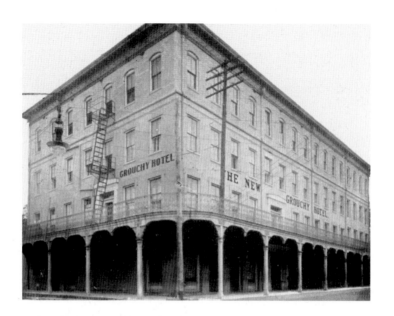

AT HOME WITH THE GROUCHY. From March 9 to 24, 1903, the Browns lodged at the Grouchy Hotel, located at Main and Lafayette. Soggy grounds kept the players hotel bound, where they exercised their elbows at slot machines and billiards. One evening, to ease the boredom, they went horseback riding through town.

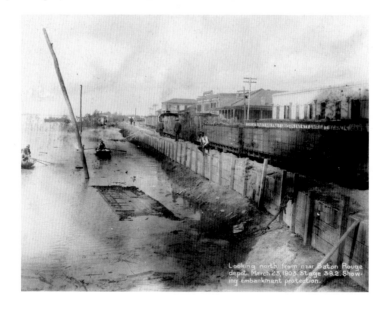

Looking north from near Baton Rouge depot, March 23, 1903. Stage 38.2. Showing embankment protection.

THE FLOOD OF 1903. Storms deluged the South during March, canceling a number of the Browns' exhibition contests. To alleviate cabin fever, the team journeyed four miles downriver of the capital on March 20 to witness a work crew of 1,500 men repair a crevasse threatening the levy. This photograph, taken near the Baton Rouge depot, shows the effects of the recent rains.

REALM OF BROWNIES AND GIANTS

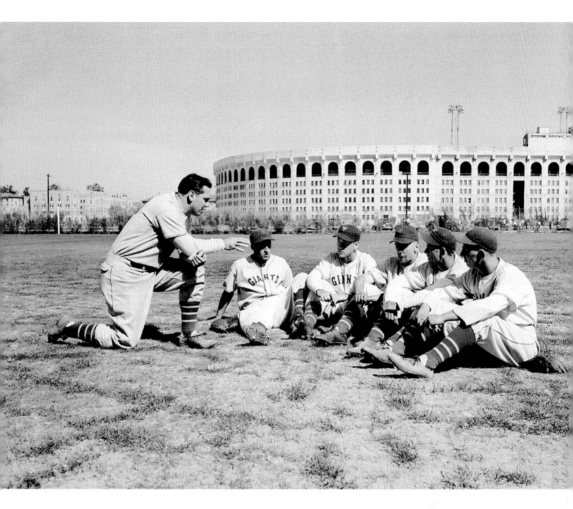

THEN THERE WERE FIVE. For a month prior to the arrival of the major-league club, the New York Giants ran a special baseball school at City Park Stadium during February 1938. Young men from across the country gathered here with the hopes of being signed to a minor-league contract. The rigorous tryouts were overseen by Giants coaches Pancho Snyder, Hank DeBerry, and Heinie Groh. When the Giants arrived at LSU, manager Bill Terry lectured the five most promising players selected from the original 147 baseball school aspirants; from left to right are Bill Terry; Don Morcel, New York City; Joe Curran, Miner Mills, Pennsylvania; Charles Oxley, Detroit; Eddie Raguskus, Manchester, Connecticut; and Henry Dvorak. Tiger Stadium looms in the background. (Courtesy of Bettmann/Corbis.)

EDDIE RAGUSKUS, 1916–1993. Eddie was one of the five players chosen from the 1938 Giants baseball school to report to New York's Class D team in Blytheville, Arkansas. The Giants befriended Eddie when they arrived in Baton Rouge for spring training. "Rowdy Richard" Bartell gave him bats, Carl Hubbell gave Eddie a pair of his old cleats, and Mel Ott supplied him with an athletic supporter. (Courtesy of Steve Raguskus.)

MOUND COMPOSER AND THE UNFINISHED STADIUM. LSU's ballpark, a WPA project, was still under construction when the Giants reported to spring training at the beginning of March 1938. Carl Hubbell, nicknamed "King Carl" and "the Meal Ticket" soft tosses in front of the unfinished bleachers in right field. His baffling screwball and 253 lifetime victories led to Hubbell's 1947 election to Cooperstown. (Courtesy of Bettmann/Corbis.)

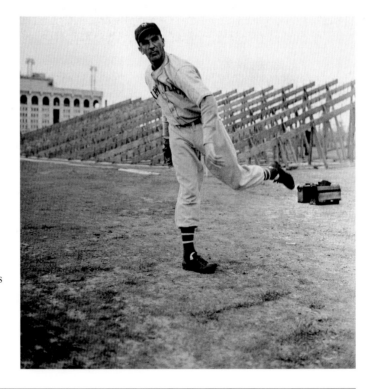

REALM OF BROWNIES AND GIANTS

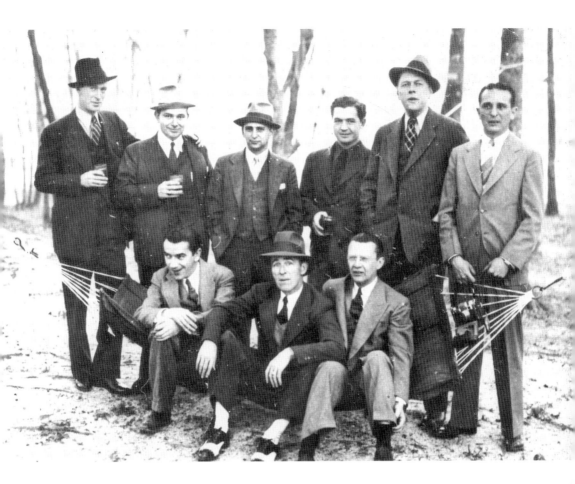

SCRIBES WITH STIFF DRINKS. This rare March 1938 photograph portrays sportswriters at the first New York Giants spring training camp in Baton Rouge. From left to right are (first row) Jerry Mitchell, Eddie Brannick, and John Drebinger; (second row) Red Broderick, Tom Meany, Ken Smith, Harry Forbes, Garry Schumacher, and Sam Andre. The ever-popular Brannick (1892–1975) started a 65-year association with the Giants as the team's office boy in 1905. Eventually he became the club's traveling secretary. John Drebinger joined the *New York Times* in 1923 and wrote the newspaper's lead story for every World Series from 1929 to 1963. Meany wrote for a number of New York papers. A few months after this photograph was taken, Schumacher coined the phrase "rhubarb" to describe a baseball brawl. Ken Smith started his career in baseball as batboy for the 1913 Danbury Hatters of the Class D New York–New Jersey League. He started writing for the *New York Mirror* in 1927. In 1963, he was named the director of the National Baseball Hall of Fame and Museum. Drebinger, Meany, and Smith are enshrined in Cooperstown's sportswriters wing. (Courtesy of the Michael Bielawa Baseball Collection.)

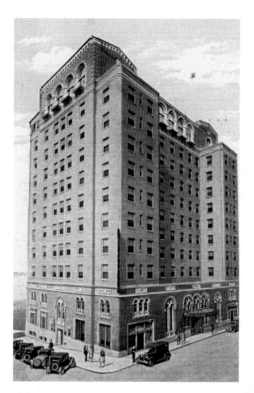

HOME OF THE KINGFISH AND KING CARL. Built in 1927, the Hotel Heidelberg was a bustling magnet for Baton Rouge politicians, reporters, and entertainers. Gov. Huey Long, known as "the Kingfish," held court here. When the 1938 Giants moved their spring training camp to Baton Rouge, they arrived as reigning world champs and lived at the Heidelberg. The team included future Hall of Fame members Mel Ott, "King Carl" Hubbell, and Bill Terry. Abandoned in the early 1980s, this architectural gem was being restored to its original art deco beauty at the time of this writing. (Courtesy of the Michael Bielawa Baseball Collection.)

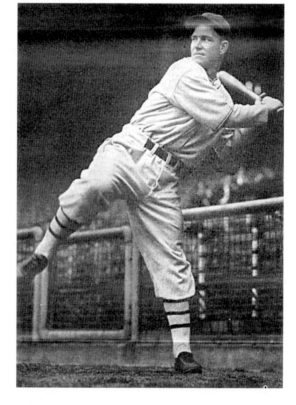

MEL OTT, 1909–1958. The first National Leaguer to reach 500 home runs, "Master Melvin" was no stranger to Baton Rouge. Born in Gretna, he visited the capital as a youngster with the semipro Patterson Grays. He was known for his unique batting stance in which he dangled his right foot in the air. In 1938, when spring training and Mardi Gras coincided, the future Hall of Famer was granted a two-day leave to take part in the revelry. (Courtesy of the Michael Bielawa Baseball Collection.)

THE BISHOP AND THE BALLPLAYER. Stanley Joseph Ott served as the third bishop of the Diocese of Baton Rouge from 1983 until his death in 1992. He drew inspiration from his cousin, Mel Ott. Although he never saw Mel play, he rooted for the Giants and was a major sports enthusiast. Wherever Bishop Ott made his presence, whether at the pulpit or visiting a local ball field, the community always considered him a dear friend. (Photograph by G. E. Arnold, copyright 1984 The Times-Picayune Publishing Company, all rights reserved. Used with permission of *The Times-Picayune*.)

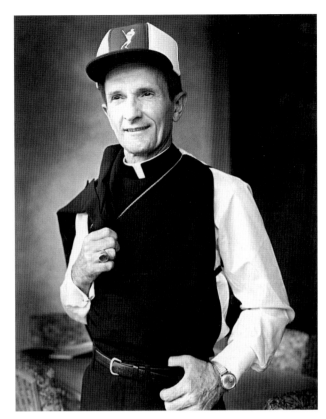

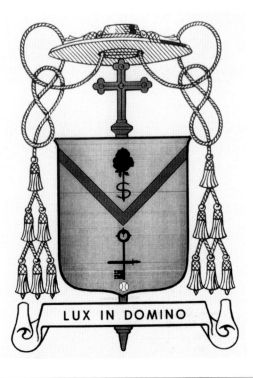

LUX IN DOMINO

STAINED-GLASS BASEBALL. As testament of Bishop Ott's appreciation for the national pastime and his family connection to baseball great Mel Ott, the bishop incorporated a baseball within his official coat of arms. The bishop's baseball joins a host of significant religious symbols and is beautifully preserved in stained glass at St. Joseph's Church in Gretna. (Courtesy of the Archives Department Diocese of Baton Rouge.)

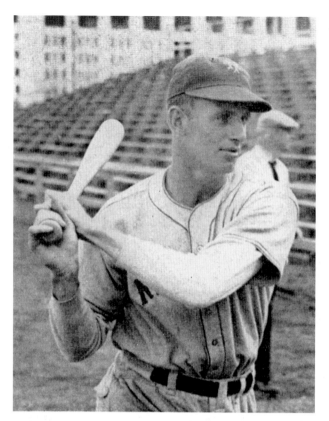

JOHNNY MCCARTHY. McCarthy had big cleats to fill when he inherited player/manager Bill Terry's first-base spot in 1937. The change worked for the New Yorkers, and the Giants captured the World Series that year. Taking advantage of the acreage at LSU's ball field in early March 1938, Johnny hit the first homer during spring training, an inside-the-park round-tripper. Omnipresent Tiger Stadium is visible behind Johnny. (Courtesy of the Michael Bielawa Baseball Collection.)

SPRING TRAINING PACKET FOR THE 1939 NEW YORK GIANTS. This unique baseball memento provides vital information concerning the Giants when they called Baton Rouge home. The folder includes a spring training schedule as well as games the Giants would play during their return trip north. A railroad itinerary posts sleeper and dinning car information for those traveling with the team. The cover of the packet features the Trylon and Perisphere, the thematic buildings constructed for the 1939–1940 New York World's Fair. (Courtesy of the Michael Bielawa Baseball Collection.)

SCENES FROM ESSO DAY AT LSU FIELD. The Cleveland Indians played Bill Terry's Giants in a spring training game on April 1, 1939. Featured clockwise from the top left, Dr. I. L. George scores the game; a Giant is at bat; a New Yorker pops-up; Esso vice president M. W. Boyer tosses the ceremonial first pitch; the Esso Refiners Band entertains between innings; and manager Bill Terry is pictured. These pictures were taken by W. A. Blackburn of the Esso Medical Department. (Courtesy of ExxonMobil.)

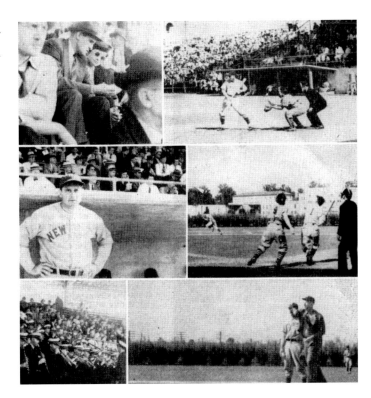

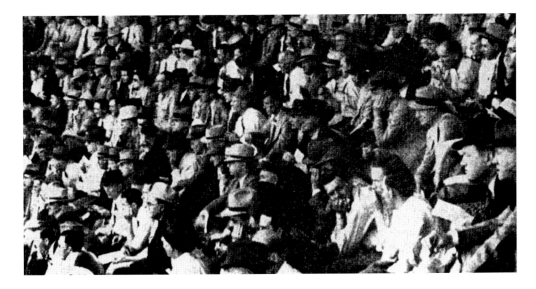

VIEW FROM THE GRAND STANDS. The April 1, 1939, game at LSU's ball field was promoted as Esso Day, and a large portion of the 2,000-plus fans on hand were members of the company's baseball booster club. The Giants beat the Indians 9-8 in 12 innings. "Harry the Horse" Danning, New York's stocky catcher, legged out a couple of triples. (Courtesy of ExxonMobil.)

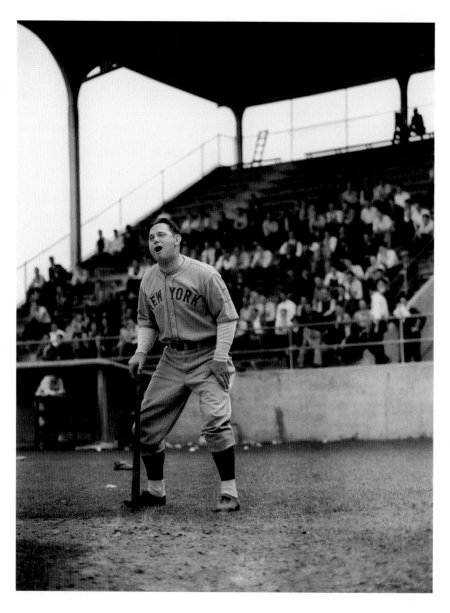

BILL TERRY HOOTS AND HOWLS. Either a great catch or rusty legs solicited a hoot of approval or howl of displeasure from Giants manager Bill Terry. He is hitting fielding practice from the first-base foul line at Governor Richard W. Leche Stadium at LSU in March 1939. This was the last year local folks had an opportunity to witness the Giants during spring training. Bill's close relationship with Esso and friendship with Gov. Richard W. Leche, along with a $10,000 retainer from the Baton Rouge city fathers, guaranteed that the capital would serve as Giants spring headquarters. Terry was an outstanding defensive first baseman during his playing days. "Memphis Bill" also batted .401 in 1930 (at the age of 31) making him the last NL player to achieve the coveted .400 mark. He was elected to the Hall of Fame in 1954. (Courtesy AP/Wide World Photos.)

REALM OF BROWNIES AND GIANTS

# BARNSTORMING IN
# BATON ROUGE

Baton Rouge has been graced with exciting baseball brought to town by traveling All-Stars, major leaguers, and professional athletes that challenged local nines. For half a century, the capital was a focal point for barnstorming baseball. These popular pre- and post-season exhibition contests were a way for professional ball players to supplement their usually meager incomes. Northern major-league clubs also barnstormed through the South on their way home following spring training. The list of teams and players visiting the city is impressive. A host of Cooperstown's immortals have kicked the earth around long-vanished Baton Rouge home plates. Ballparks once located near the Capitol building, along Nineteenth Street and under today's Interstate-10 exit at Darlymaple Drive saw John McGraw, the Bambino, Larry Dolby, and Roy Campanella in action. Teams often arrived by railroad and were treated like royalty, greeted with a band and accompanied by a festive parade to the ballpark or hotel where the players were staying. The LSU Tigers regularly played pro squads from both the minor and major leagues. The practice ceased when games endangered the college players' amateur status. This chapter features only a fraction of the countless players and teams that passed through Baton Rouge.

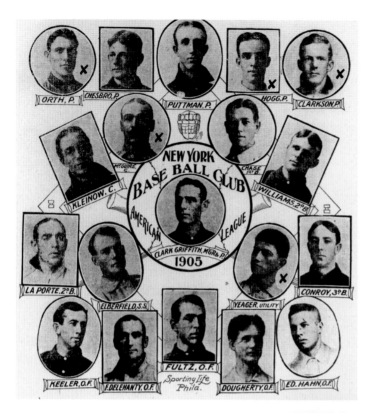

DAMN HIGHLANDERS. The New York Highlanders played the Baton Rouge Cajuns at Battle Park on March 26, 1905. Baton Rouge lost 3-1. New Yorkers that played in Baton Rouge that day are indicated with an "X." Around this same time, sportswriters were dubbing the Highlanders the "Yankees," a name that became official in 1913. (Courtesy of the National Baseball Hall of Fame Library, Cooperstown, New York.)

DEAN OF SPORTSWRITERS. As a major-leaguer, Sam Crane (1854–1925) had a lackluster career, barely batting over .200 after seven seasons. But he was a heavy hitter when it came to the newspaper game. Accompanying the touring Highlanders for the *New York American and Journal*, the venerable reporter complimented the city: "Of all the places [the Highlanders visited] Baton Rouge took my fancy the most. . . . Baton Rouge is a pretty little city." (Courtesy of Stephen Milman.)

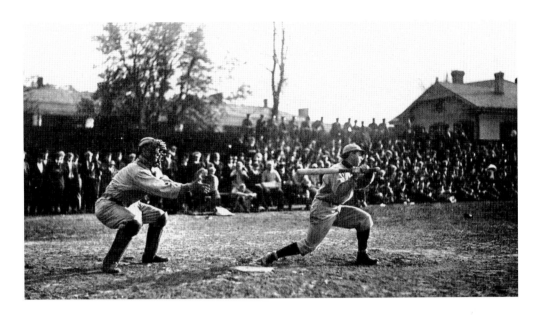

TIGER VS. TIGER. This photograph shows how large crowds gathered March 18 and 19, 1913, to see the major-league Detroit Tigers play the LSU Tigers. The university squad lost by scores of 17-0 and 13-5. During these years, the school's downtown diamond was situated south of the Third Street Pentagon Barracks. (Courtesy of LSU Libraries' Special Collections, Baton Rouge.)

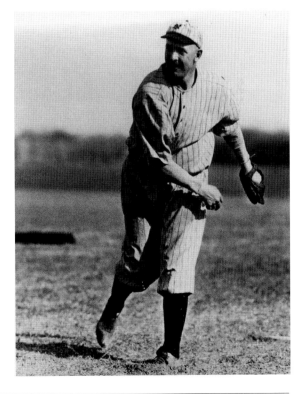

BIG SIX IN BATON ROUGE. Christy Mathewson, nicknamed "Big Six," was a member of the inaugural five players inducted into the Hall of Fame in 1936. Mathewson and John McGraw's New York Giants played LSU on April 3, 1916. It was Mathewson's first outing that year. The *State-Times* reported, "Proud parents brought their children to [Christy] in order that in later years they would have the privilege of stating they had shook hands with him." (Courtesy of National Baseball Hall of Fame Library, Cooperstown, New York.)

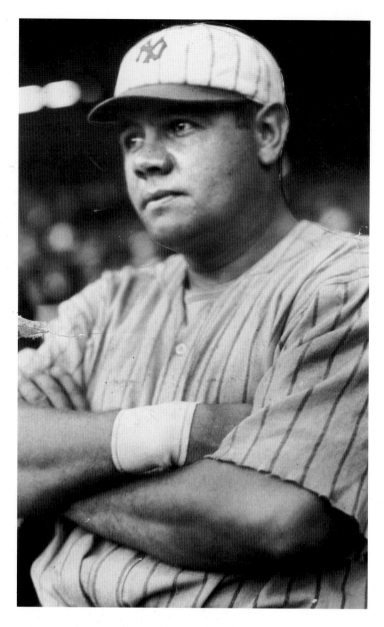

THE ONE AND ONLY BABE. The Yankees arrived in Baton Rouge for an exhibition game against the NL Brooklyn Dodgers on March 18, 1921. Already wildly popular everywhere he traveled, Ruth was recognized as "the king of baseball players" in that afternoon's *State-Times* newspaper. A large cheering crowd greeted the team's special train at Union Station at 12:20 p.m. With the Stanocola band in the lead, hundreds of jubilant fans escorted Babe on his march to the Capitol, where the slugger was introduced to Gov. John Parker and presented with a bouquet of roses. Amid the pageantry when asked what he thought of the city, the Bambino innocently exclaimed, "I like Baton Rouge fine." (Courtesy of National Baseball Hall of Fame Library, Cooperstown, New York.)

BARNSTORMING IN BATON ROUGE

HALL OF FAMER UNCLE ROBBIE. Baseball savvy and his good nature led Wilbert Robinson to the managerial job of the Brooklyn Dodgers. The team was affectionately dubbed the "Robins" during his tenure. In one of the club's first games following their 1920 pennant-winning season, Brooklyn visited Baton Rouge on March 18, 1921, to play the New York Yankees. Robinson, Babe Ruth, Gov. John Parker, Mayor Alex Grouchy, and Charles Ebbets gave speeches at the Mayer Hotel. (Courtesy of National Baseball Hall of Fame Library, Cooperstown, New York.)

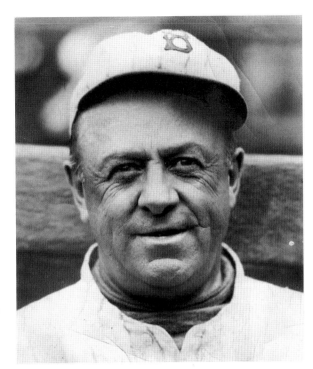

NEVER CALL HIM CATFISH. Hall of Fame umpire Bill Klem officiated the game in Baton Rouge between the Dodgers and Yankees. Said to have resembled a catfish, he took umbrage to anyone mentioning this fishy opinion. Klem tossed Yankees outfielder Bobby Roth in the eighth for arguing a called third strike. Roth said something while returning to right field that caused his removal. It isn't known whether the disgruntled Roth uttered the dreaded fish moniker. (Courtesy of National Baseball Hall of Fame Library, Cooperstown, New York.)

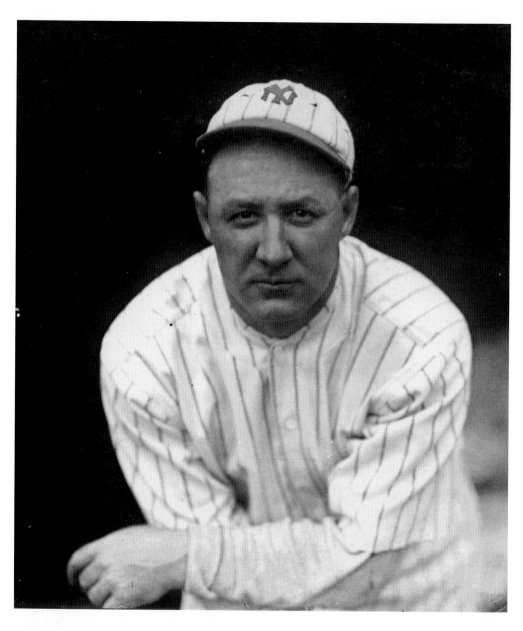

THEY CALL ME PING BODIE. This New York outfielder's accepted name has a unique origin. "Ping" mimicked the sound of a baseball off of his bat, while the "Bodie" surname was derived from the California town where he once lived. As the Yankees filed into the Louisiana governor's office on March 18, 1921, the gregarious Bodie found himself officially introducing each member of the team to Gov. John Parker. Bodie is credited with one of the great baseball quotes of all time. Ping roomed with Ruth when the slugger first arrived in New York. When reporters asked Bodie what it was like to room with gadabout Babe Ruth, Bodie remarked, "I don't room with Ruth. I room with his suitcase!" (Courtesy of National Baseball Hall of Fame Library, Cooperstown, New York.)

THE BABE'S STAGE. When the 1921 Yankees and Brooklyn Dodgers crossed bats at Louisiana State University, the ball field was located at the old downtown campus north of the Pentagon Barracks. A crowd of 5,000 watched the Yankees win 7-4 in 11 innings. Ball games were played at this site until the late 1920s. (Courtesy of Southeastern Louisiana University, Linus A. Sims Memorial Library.)

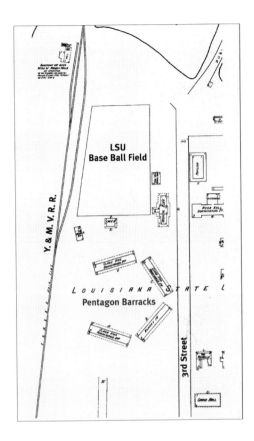

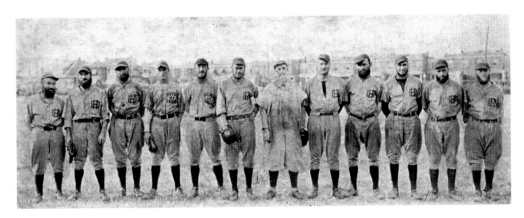

BASEBALL'S BEARDED BARNSTORMERS. On April 11, 1931, Baton Rouge was visited by one of baseball's most unique spectacles, a touring House of David team. Originally a Michigan religious colony established by Benjamin Purnell in 1903, followers did not shear any hair from their heads. Outstanding whiskered ballplayers with long flowing hair traveled the country raising money for the sect. The formula proved so successful that imitators, like this club led by Louis Murphy, organized. (Courtesy of the Michael Bielawa Baseball Collection.)

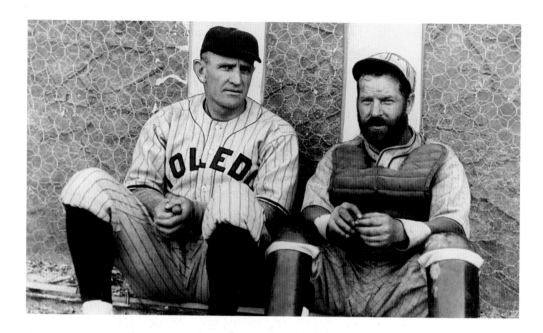

BEARDED CAPTAIN. Louis Murphy's House of David team played Standard Oil in 1931. Before his defection, Murphy had been a promoter with the original Michigan team. Eventually the House of David recognized his squad and allowed it to legally utilize the House of David name. This photograph of team captain Kelly Herbst (right) was taken with Casey Stengel two weeks prior to their visit to Baton Rouge. The Standard Oil team was defeated 8-4. (Courtesy of the Michael Bielawa Baseball Collection.)

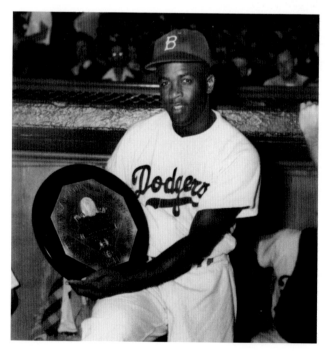

JACKIE ROBINSON ALL-STARS. Robinson was named the 1949 National League MVP. Following the postseason, Roy Campanella and Larry Doby set out on a barnstorming tour with the Jackie Robinson All-Stars. On Sunday, October 23, 1949, Jackie's team stopped in Baton Rouge for a game against the Creole All-Stars of New Orleans. The 8,000 jubilant fans filling City Park Stadium made it one of the largest gatherings in the ballpark's history. (Courtesy of the Michael Bielawa Baseball Collection.)

EDNA JORDAN SMITH REMEMBERS JACKIE. Edna saw Robinson's All-Stars at City Park in 1949: "My mother Christine Jordan was ecstatic, Jackie passed right in front of us coming into the stadium! We were there for the game but that was a real bit of lagniappe to see Jackie so close!" In the first inning, Campanella stroked a three-run homer followed by Robinson's solo blast. Jackie's team won 9–2. Edna beams, "I will never forget Jackie's home run as long as I live." (Courtesy of Edna Jordan Smith.)

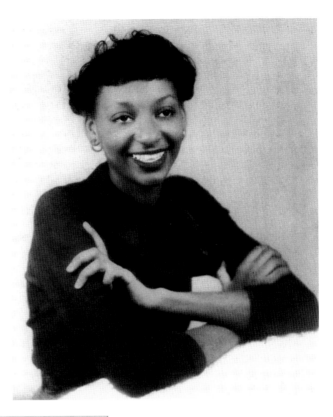

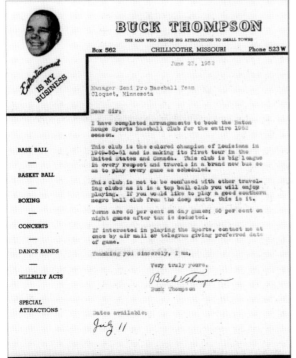

HARDWOOD SPORTS. Buck Thompson, promoter for one of Baton Rouge's finest teams, the Hardwood Sports, sent this letter to the manager of a Minnesota semipro club arranging a barnstorming game. Thompson states that the "club [Sports] is the colored champion of Louisiana in 1949–50–51 and is making its first tour in the United States and Canada." The letter stresses the Sports are a top-notch club and will make all scheduled games traveling in their new bus. (Courtesy of Michael Plymill.)

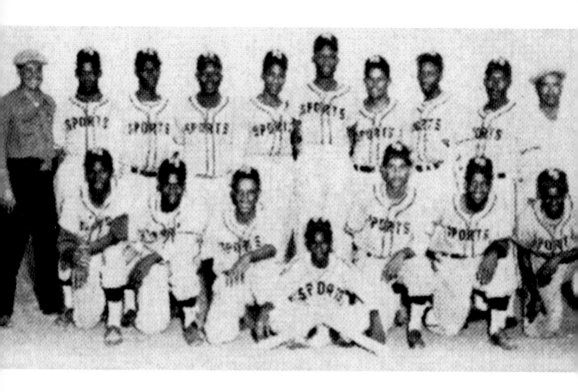

HARDWOOD SPORTS BARNSTORM NORTH. In 1952, the Hardwood Sports defeated the Regina Caps 4-2 in the semifinal round of the National Baseball Congress's Indian Head District tournament, which took place in Saskatchewan, Canada. The Florida Cubans then beat the Sports in the deciding game 6-4, walking away with the $1,300 prize and the Coca-Cola Bottler trophy. The Hardwood Sports, pictured here, finished the tournament in a respectable second place out of 16 teams; the team includes Robert Jackson, catcher; Ernest Davis, first base; Ira Lee Mobley, second base; Robert Knight, third base; Hector Valdez, shortstop; Johnny Lloyd, left field; William Breda, center field; Levi Clark, right field; J. P. Mays, utility; Eddie Brown, utility; O. B. Robison, pitcher; Frank Pickens, pitcher; Nathaniel Booker, pitcher; and Willie Jefferson, pitcher. Hardwood Sports players named to the All-District team included Robert Jackson, O. B. Robison, and William Breda. (Courtesy of National Baseball Congress, Wichita, Kansas.)

# POWERED BY ESSO

Standard Oil moved to Baton Rouge in 1909. By 1911, they were officially known as the Standard Oil Company of Louisiana (Stanocola). During the turbulent decades of the 1930s and 1940s when the nation was mired in the Great Depression and World War II, the oil giant, known by then as Esso, provided Baton Rouge with jobs while raising the city's morale with recreational diversions. As far back as the 1920s, refinery employees were encouraged to participate in sports. Basketball, tennis, golf, horseshoes, and other activities were organized. Men were invited to join both hardball and softball teams in the 1930s. When the professional team, the Solons, abandoned Baton Rouge in 1934, the Essos carried baseball's banner for the capital. These incredibly talented semipro clubs were often composed of former professional players. Each year, the oil company conducted high-caliber tryouts during February and March featuring calisthenics, running, pepper ball, and scrimmage games.

Dubbed the Stanocolas and later the Standards during the 1920s and the Essos beginning in 1935, they played their home games at Standard Park and City Park Stadium. The refinery men went up against strong semipro and pro teams from throughout the region and played in state and national semipro championship tournaments. The team often participated in charity games benefiting hospitals and entertaining folks confined at the Carville leper facility.

Softball was played, too. Interdepartmental teams played on diamonds carved out of the front lawn of the company's main building. Teams were named after their departments such as Process Engineers, Stenographers, Medical, and Stationary. Esso's official softball 10 would play before crowds of 3,000 during state championship games.

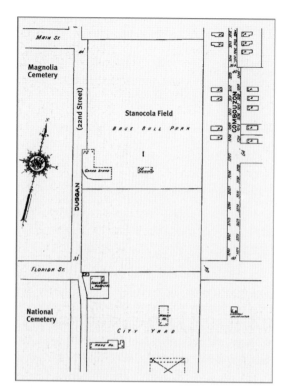

STANOCOLA FIELD IN 1923. The home of the Standard Oil baseball team was located on Duggan Lane, now Twenty-second Street, across from Magnolia Cemetery. The Stanocolas played here during the 1920s. The Cotton States League Highlanders also played here. Children would wait for foul balls to sail over the third-base wall and then stage a bicycle relay through Magnolia Cemetery to hold onto them. These souvenirs were collected and exchanged for game tickets. (Courtesy of Southeastern Louisiana University, Linus A. Sims Memorial Library.)

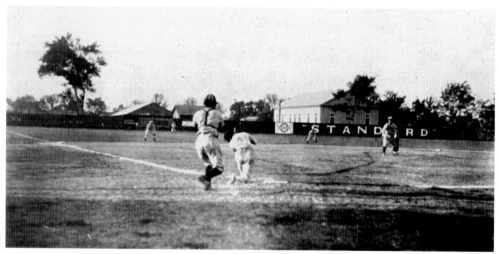

STANOCOLA/STANDARD FIELD 1927. This striking photograph provides an excellent view from the grandstands. The Standard Oil team, the Standards, is playing LSU. The scoreboard is visible in the left-field wall. The stadium's community-minded namesake is proudly painted along the outfield fence.

The original Sacred Heart of Jesus Christ Church, built in 1925, is the building situated beyond "Standard" sign. The present-day Sacred Heart Church occupies the same site. (Courtesy of LSU Libraries' Special Collections, Baton Rouge.)

STANDARD OIL'S GREATEST BALLPLAYER. Ballplayer Bill Terry's concern for his family's finances convinced him to leave Shreveport's minor-league club. In 1918, he moved to Tennessee and joined Standard Oil's Memphis sales office. The following summer, Bill organized that department's semipro baseball squad. In the early 1920s, Terry travelled from Memphis to play with the Baton Rouge team during important semipro games. He was rediscovered with the Memphis team and signed by the Giants. Terry was proud of his association with Esso and for years worked for the company in a public relations capacity. (Courtesy of ExxonMobil.)

THE ORIGINAL GAS HOUSE GANG. Danny Barfield (left) began playing for Standard Oil around 1920. Esso eventually ceased fielding a team in 1929, but in 1935 when they reorganized, Barfield was named business manger and third baseman. He was regarded as "the moving spirit" of the reborn Essos. Second baseman/field manager Baxter Crawford dates his Stanocola baseball days back to the early 1920s. Crawford managed the team to three state championships and two Bi-State crowns. (Courtesy of ExxonMobil.)

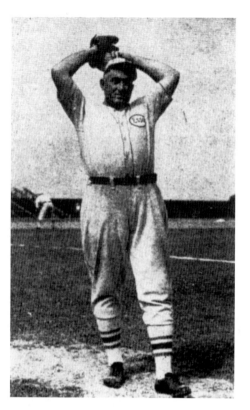

HOW TO MAKE AN OLD ORIOLE HAPPY. "Bullet Joe" Manda began pitching for Stanocola about 1922. During the 1938 championship series against Mississippi, an Esso pitcher surprised everyone by tripling off the right-center field wall. Joe, coaching third, asked the opposing hurler to toss the ball to him so he could examine it. The ball was still in play and the runner broke for home scoring on the "not so hidden ball" trick. Joe managed the Baton Rouge All-Stars during 1944–1945. (Courtesy of ExxonMobil.)

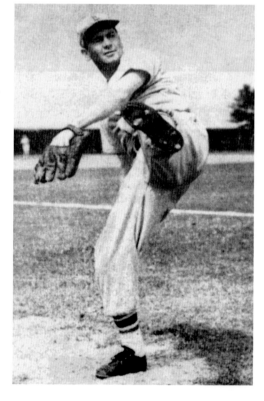

MANAGER PEABALL. Bryan Wasson Flanagan's 261 strikeouts with the McCook team of the Nebraska State League in 1932 was tops in all of baseball. Standard Oil hired Flanagan in 1935, and he began hurling for the Essos the following season. This right-hander's fastball earned him the nickname "Peaball" around the refinery. Elected manager for 1940, Peaball served in this capacity until 1942 and again after the war from 1946 to 1947. (Courtesy of ExxonMobil.)

POWERED BY ESSO

BENJAMIN H. SEGREST. Born in 1905, Ben, a resident of Baton Rouge, pitched for the House of David team. The 1930 census listed his official occupation as "Ball Player." In 1934, Segrest pitched professionally for Baton Rouge, Clarksdale, and Lafayette. He managed the Rayne Rice Birds of the Evangeline League in 1935, where he posted a 15-12 pitching record. In early 1936, Ben took a job with Esso and began his semipro career. (Courtesy of ExxonMobil.)

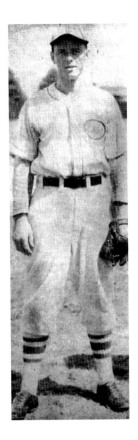

CLINTON JONES. Clinton Jones's sports career began at Mississippi College. He played professional ball for the Jackson Senators and Opelousas Indians. He batted .350 in the Evangeline League and jumped to the Western League in 1935, just two levels below the majors. An arm injury kept him out of the major leagues. He was hired by Esso and played first base for the refinery team from 1936 to 1940. (Courtesy of ExxonMobil.)

MARION JONES. Born in McCall Creek, Mississippi, in 1913, Marion was known as "Beany" at the refinery. He was the younger brother of Clinton. Beany played the keystone position during the Essos early championship years 1937–1939. He is seen here during practice pivoting to turn a double play. Beany left Standard Oil to play pro baseball for Daytona Beach in 1940. In 1941, he batted .299 for Mount Airy of the Bi-State League. (Courtesy ExxonMobil.)

UNCLE BEANY AND THE MAJOR LEAGUER. The Jones family loved baseball. Esso's Marion Jones squats behind a cardboard home plate while his five-year-old nephew, Dalton, takes his cuts. Beany, and especially Dalton's dad, Clinton, imbued the youngster with their baseball savvy. The young boy's dream of playing major-league baseball would one day become a reality. This shot was taken at the Jones residence on Delaware Street about 1948. (Courtesy of Dalton Jones.)

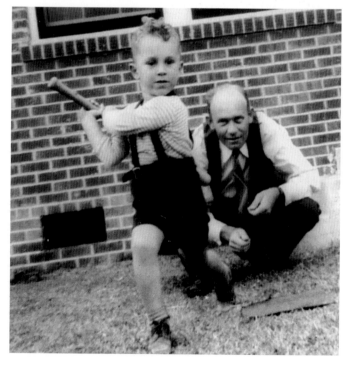

FRED GOURRIER. Fred played with the Cotton States, Dixie, Evangeline, and East Dixie Leagues from 1931 to 1935. He played infield with Pine Bluff, Opelousas, Alexandria, and Clarksdale and was a member of the Baton Rouge championship teams in 1932 and 1933. During the latter campaign, he batted .328. His son John Fred Gourrier formed the band John Fred and the Playboys and wrote "Judy in Disguise (With Glasses)" which became a number-one hit. (Courtesy of ExxonMobil.)

FIELD CAPTAIN FRED. Gourrier began his hot corner career with the refinery crew in 1936. A dependable defensive third baseman, he also wielded a quick stick. Always hitting around the .300 mark, he occupied a power slot in the middle of the lineup. Gourrier's teammates selected him MVP of 1939. Midway into the 1940 campaign, manager Flanagan switched Fred to left field. Gourrier managed the Essos during 1948. (Courtesy of ExxonMobil.)

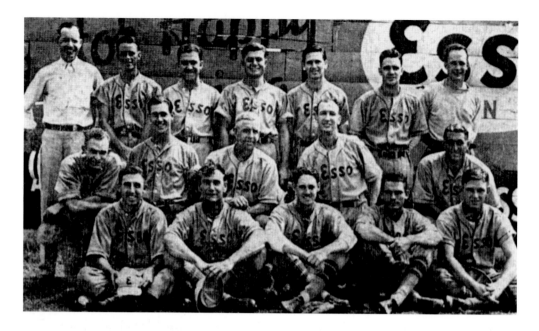

Esso Team, 1936. This squad brought together veteran player/workers and new employees. When these teammates crystallized, they set the stage for a championship dynasty. From left to right are (first row) Baron, Gilbert, Morgan, Croswell, and Gourrier; (second row) C. Jones, Brupbacker, field manager Pezold, Edwards, and Manda; (third row) Barfield, Segrest, Bauman, Pollard, Flanagan, Inbau, and Allison. (Courtesy of ExxonMobil.)

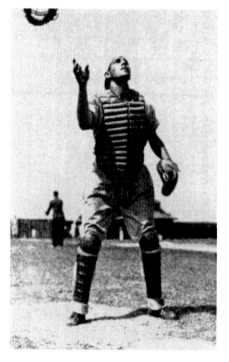

The Man Behind the Catcher's Mask. Antoine "Tony" John was born in Lafayette, Louisiana, on February 28, 1914. He was a first-generation American, his parents having emigrated from Syria. Tony played high school and American Legion ball as well as semipro in Franklin. The catcher was recruited by Standard Oil and began playing for the Essos in 1938. The backstop became a fixture for the refinery squad. Tony eventually became the team's player/manager in 1949. (Courtesy of ExxonMobil.)

POWERED BY ESSO

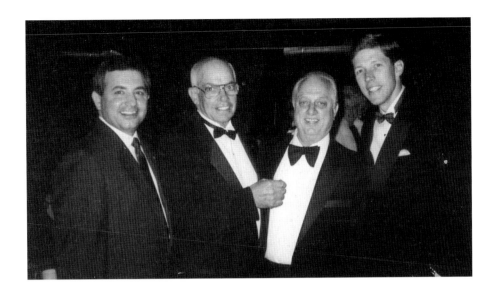

TONY JOHN THE SCOUT. Tony's playing days ended at Esso but never his love of baseball. For decades, Tony scouted for the Dodgers. In 1989, he attended his dear friend Tommy Lasorda's induction ceremony into the National Italian American Sports Hall of Fame. Shown here from left to right are Tony's nephew, Louisiana State Representative Ronnie Johns; scout Tony John; Baseball Hall of Famer Tommy Lasorda; and Dodger pitching sensation Orel Hershiser. Tony John passed away in 1991. (Courtesy of Louisiana State Representative Ronnie Johns.)

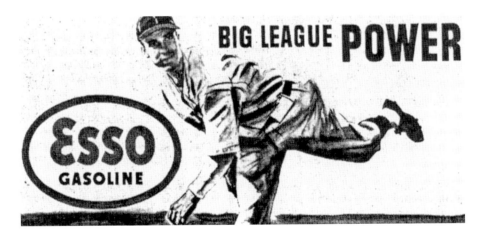

MADISON AVENUE ON THE BAYOU. Baseball's popularity has always made it a natural advertising tool. Special images readily convey a message in a magazine or on a highway billboard, such as this 1939 advertisement. These are American symbols with communicative clout: a power hitter represents strength, a catcher's equipment exemplifies safety, while a child and police officer sharing a peek at a game through a knothole symbolizes understanding. Esso successfully coupled its products with the nation's number-one game. (Courtesy of ExxonMobil.)

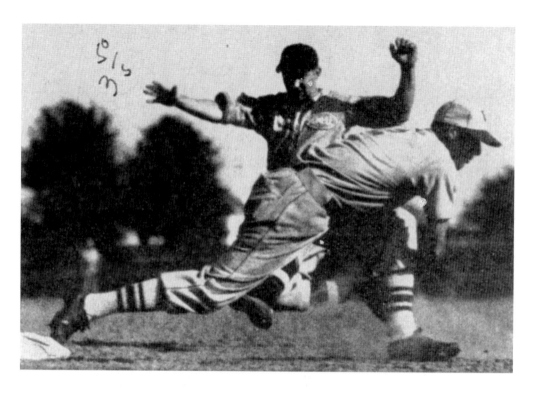

DAVID O'BRIEN. D. J. O'Brien began playing the hot corner for the Essos in 1940. He is seen here scooping a low throw for a force out at third. Born in Bellevue, Texas, in 1914, he batted .326 for the champion 1938 Evangeline League Lake Charles Skippers. (Courtesy of ExxonMobil.)

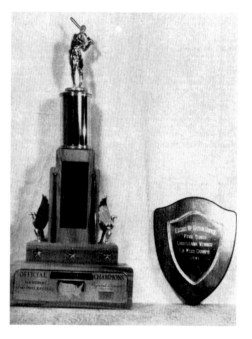

LAURELS FROM AN INNOCENT AGE. Throughout 1941, the world was aflame—except for the United States. In that last summer before Pearl Harbor, the Esso ball club won its fifth-straight, state semipro crown. The towering trophy on the left was awarded to Esso for taking the Louisiana title. On the right rests the plaque commemorating Esso's victory in the 1941 Bi-State tournament over neighboring Mississippi's semipro champs. (Courtesy of ExxonMobil.)

POWERED BY ESSO

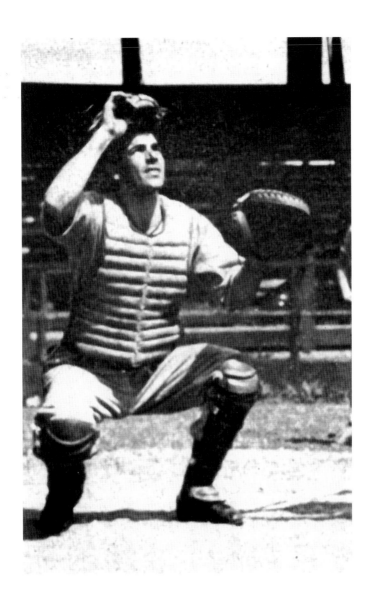

WAR IMPACTS BASEBALL. In early May 1943, it was announced that Standard Oil of Louisiana would not field a baseball team. Gas rationing took hold in America during World War II to ensure wartime supplies overseas. The Essos reasoned that gasoline was too precious a commodity for bus travel during road games. Fuel used by teams visiting Baton Rouge plus all the fans driving to and from City Park was too crucial to expend. In addition, Esso employees were working longer shifts in their essential war-related jobs. It was difficult to field an entire team, let alone schedule and hold practices. However, later that summer to help raise morale, Esso catcher Tony John, pictured here at City Park Stadium, organized the Baton Rouge All-Stars. The team was composed of semipro players from throughout the state along with a core of Esso players. The All-Stars took part in a weeklong tournament at LSU's newly renamed Alex Box Stadium at the end of July and the beginning of August 1943. (Courtesy of ExxonMobil.)

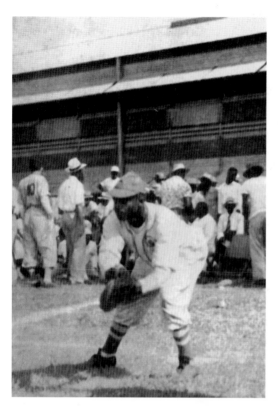

A CHANGING AMERICA. When segregation was a harsh reality of American life, ball teams were arranged by skin color. Esso, like other major corporations, sponsored baseball teams composed of black employees and white employees. This photograph shows Calvin Washington, catcher for the Esso Regulars, in a photograph taken during the late 1940s. In the 1920s, the black team was named the Socolas. Jackie Robinson broke major-league baseball's color barrier in 1947, changing baseball and America forever. (Courtesy of ExxonMobil.)

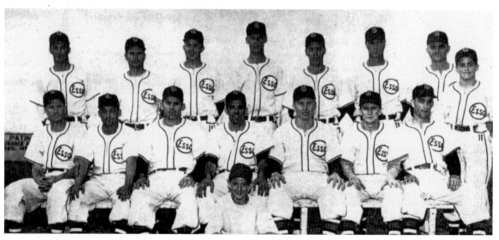

ESSO OILERS, 1950. At the half century mark, Esso was still number one in Louisiana's semipro circuit under player/manager Tony John. Members of the squad had played professionally before joining the refinery. From left to right are (seated) James McDowell, Ralph Snyder, T. J. Bankston, Tony John, Fred Hall, Bobbie Batten, Dick Colvin, and mascot Mickey Green (on the ground); (standing) George Hamilton, Roy Smith, Bryan Hammett, James Gremillion, Jimmie Carlin, Jack Bolin, Dick Korte, and batboy Donnie Fetzer. (Courtesy of ExxonMobil.)

POWERED BY ESSO

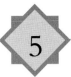

# THE
# EVANGELINE LEAGUE—
# WHOLLY LOUISIANA!

Named after Longfellow's Acadian heroine, the Evangeline League was born in 1934. At the outset, cities representing the Class-D circuit were mostly scattered throughout rural Louisiana and did not include Baton Rouge. By the beginning of the 1940s, Natchez and Port Arthur joined the loop, but the league succumbed to World War II (1943–1945). It could never be said that the Vangy wasn't exciting. Nicknamed the "Hot Sauce League," the circuit was well known for its rowdy and unsavory shenanigans. Teams were funded by local slot machines, it was rumored a stadium was set ablaze due to unscrupulous financial dealings, passionate fans attacked umpires, and players were investigated for throwing games. When Baton Rouge was considered for a team in the late 1930s, critics questioned whether or not the city should join such a dubious circuit. However, baseball people always respected the league. Clubs provided talented players and teams were a source of community pride.

Following the war, a somewhat polished Evangeline League emerged. New league president J. Walter Morris (a former president who was fired in 1938 for skimming from the league's ledgers) contacted one-time Texas League player John Paul Jones. Jones, a man with baseball and business connections, worked in LSU's maintenance department and was invited to spearhead the establishment of a Baton Rouge franchise. The Red Sticks were born. In 1949, the league was elevated to Class C. The team changed their name to the Rebels in 1956.

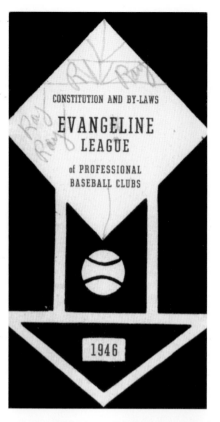

COVER OF THE 1946 EVANGELINE LEAGUE CONSTITUTION AND BY-LAWS. Baton Rouge entered the Vangy in 1946. Not only did this book outline the league's rules of play, it also explained what was expected of teams. For instance, grandstand admission prices could not be less than 60¢ a seat. Bleacher seats had to be sold for at least 40¢, while children less than 12 years old had to pay at least a quarter. (Courtesy of Evangeline Baseball League Collection, Archives and Special Collections, Nicholls State University, Thibodaux, Louisiana.)

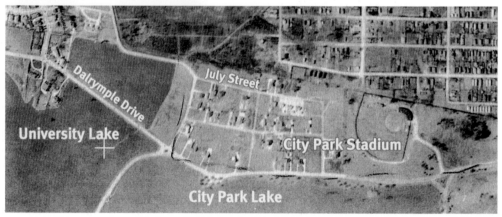

HOME OF THE RED STICKS. This aerial photograph of City Park Stadium was taken in early 1941. Night games had just become possible when lights were installed a few months earlier in June 1940. The Evangeline League Red Sticks played at City Park from 1946 to 1955. The area was commonly referred to as "the hilltop." Today I-10 passes directly over the diamond and outfield at the Dalrymple Drive Exit 156B. This photograph was initially labeled "Secret" by the government. (Courtesy of Department of Public Works, Engineering Division, City of Baton Rouge.)

IRVIN STEIN: PRESENT AT THE CREATION. Madisonville, Louisiana, native Irvin Stein was the first manager of the Red Sticks. He appeared in one major-league game with the 1932 Philadelphia A's. Stein fared much better hurling for the Sticks. With Baton Rouge, he posted a respectable 3.52 ERA and a record of 10-10. However, at the helm of the 1946 Sticks, he did not fare well. The club finished seventh out of eight teams. (Courtesy of Joe Stein.)

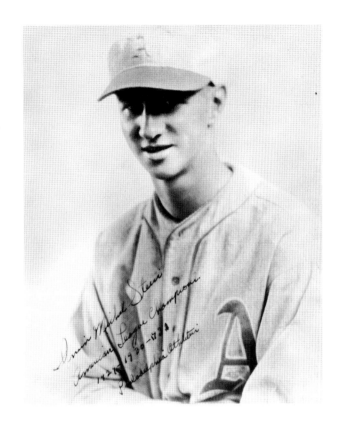

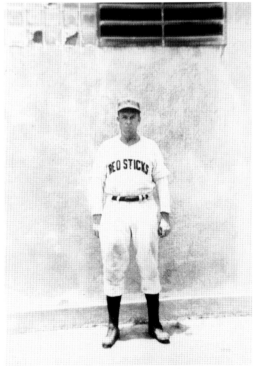

GLENN MURRAY. Born in 1915, Murray was the only position player to return as a member of the Red Sticks during the team's first two seasons. He hit for a .328 clip in 1946 and repeated his slugging success with a .319 average in 1947. His two season totals with Baton Rouge amounted to 22 home runs and 142 RBIs. Murray passed away in Baton Rouge in November 1991. (Courtesy of the Evangeline Baseball League Collection, Archives and Special Collections, Nicholls State University, Thibodaux, Louisiana.)

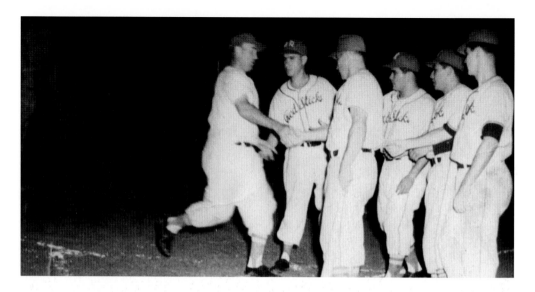

LONG BALL HEROES. This unidentified photograph from about 1950 shows Red Stick players greeting a teammate following a round-tripper. The standout home run kings of Baton Rouge throughout the Evangeline years include Lou Heyman with 32 homers in 1948, Bill Radulovich with 31 in 1951, and Rogers McKee with 33 in 1954. (Courtesy of the Evangeline Baseball League Collection, Archives and Special Collections, Nicholls State University, Thibodaux, Louisiana.)

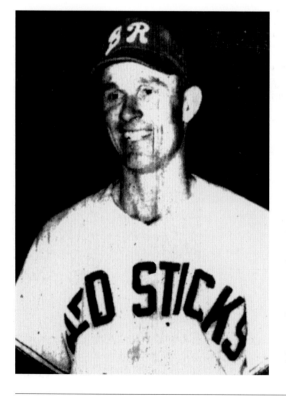

RED MURFF: 1950 EVANGELINE LEAGUE ROOKIE OF THE YEAR. Murff's 17 wins in 1950 propelled the Red Sticks into the postseason. The right-hander also batted .331 and plated 65 runners. A year later, he hurled a no-hitter with Texas City of the Gulf Coast League. Pitching with the Milwaukee Braves in 1956, Red injured his arm during his first outing: "The injury stopped my baseball career as a player. But baseball was still part of my life." (Courtesy of Red Murff.)

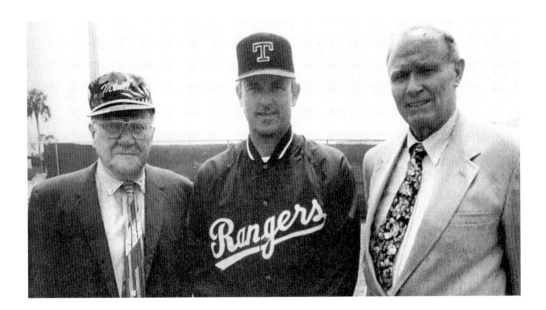

SENSATIONAL STICK TURNS SUPER SCOUT. One Red Stick in particular has had a resounding impact on baseball. As a scout for the Mets, Red Murff helped build their 1969 miracle team. Red signed Nolan Ryan, Jerry Koosman, Jerry Grote, and Ken Boswell. Ryan credits Murff's assistance with making him the Hall of Fame pitcher he became. Pictured here from left to right are scout Earl Halstead, who signed Murff to the Braves; Nolan Ryan; and Red Murff. (Courtesy of Red Murff.)

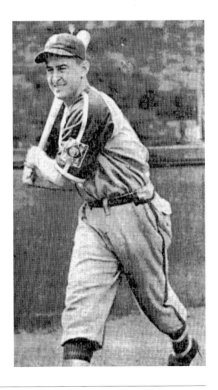

VANGY CHAMPS, 1950. In 1949, the Red Sticks finished dead last. The following season, over 100,000 fans came out to City Park Stadium to watch the Sticks. Pitcher/manager Paul Bruno guided Baton Rouge to a second-place finish, just four-and-a-half games behind the Lafayette Bulls. Bruno led the team in ERA (1.73) and owned a healthy 7-2 mound record. In the playoffs, the Sticks topped Thibodaux and then swept Hammond to take the Shaughnessy championship series. (Courtesy of Lenny Yochim.)

National Association of Professional Baseball Leagues

CLASS C

INSTRUCTIONS: Use Box #1 only when player is transferred off active list because of suspension, temporary inactivity or disability. When player is reinstated make out new forms and use Box #2 only.

PRINT OR TYPE.

MAIL ONE NOTICE AT ONCE TO: (1) President National Association.
(2) President of your League.
(3) Hand one to player. (If not possible, mail copy to player by REGISTERED MAIL.)
(4) Retain one copy for your files.

BOX No. 1    NOTICE TO PLAYER OF TRANSFER FROM ACTIVE LIST

July 18, 1950
Date

To Player    Rudy Belakovy

Cross out terms which do not apply

You are hereby officially notified of your placement upon the ~~SUSPENDED~~ ~~TEMPORARILY INACTIVE~~

DISABLED

list effective this 18 day of    July    1950  For a term of    10    days

Reason:    Injured back.

Baton Rouge Baseball    Club    Evangeline    League

By    Arthur Jones    President
Title

RECORDED

RECEIPT    9    JUL 21 1950
July 18, 1950
GEORGE M. TRAUTMAN
PRESIDENT    Date

RECEIPT OF COPY OF THIS OFFICIAL NOTICE IS ACKNOWLEDGED

Rudy Belakovy    Player

Place X in box if player is sent copy by registered mail.    ☐ PLAYER SENT COPY OF THIS OFFICIAL NOTICE BY REGISTERED MAIL.

BOX No. 2    NOTICE TO PLAYER OF REINSTATEMENT TO ACTIVE LIST

To Player
Date

Cross out terms which do not apply

SUSPENDED

You are hereby notified of your reinstatement from TEMPORARILY INACTIVE list to the active list this
DISABLED

day of    194

Club    League

By
Title

STICK LEFT-HANDER HITS DL. Rudy Belakovy's mound record was 8 wins and 8 losses during the Red Stick's 1950 championship season. In June, Belakovy went on the disabled list. A shaky performance after being reinstated led to his returning to the DL on July 18, as this document illustrates. He won just one game after that. The year's end found Rudy demanding his release, and the matter was referred to National Association president George Trautman. (Courtesy of Michael Bielawa Baseball Collection.)

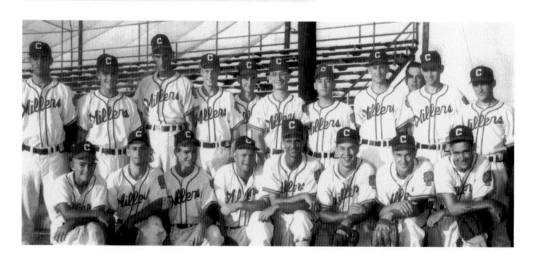

CROWLEY MILLERS DEFEAT RED STICKS, 1952. Named in honor of Crowley, Louisiana's rice industry, the Millers completed the second year of their Evangeline League existence tops in the Pepper Pot loop. Crowley took the crown in dramatic fashion. After sweeping the Lafayette Bulls in the first round of postseason play four games to none, they advanced to the finals and repeated their shutout march, defeating Baton Rouge four games to none as well. (Courtesy of Richard Pizzolatto.)

ROGERS HORNSBY MCKEE. McKee is the youngest pitcher in the 20th century to win a major-league game. Born on September 16, 1926, he debuted with the Philadelphia Phillies on August 18, 1943, and won his first game on October 3 of that same year. That makes him 17 years and 17 days old at the time. Bob Feller was 17 years, 9 months, and 20 days when he notched his own initial win. (Courtesy of Rogers Hornsby McKee.)

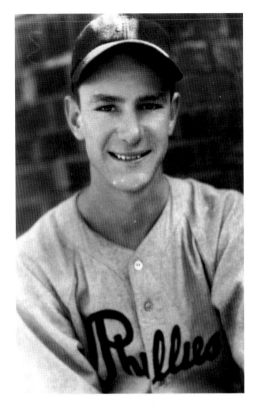

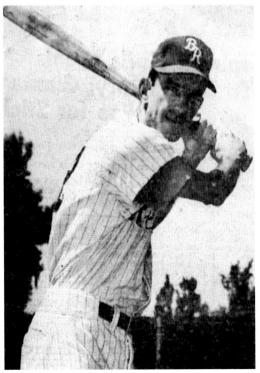

ROGERS THE RED STICK. Because of gas rationing, spring training camps remained close to Northern major-league parks during World War II. On a cold Wilmington, Delaware, day in 1944, McKee hurt his pitching arm. Following a hitch in the navy, Rogers converted to the outfield and became and exceptional hitter in the Evangeline League, batting .357 his first year with the Red Sticks. He played with Baton Rouge from 1953 to 1954 and 1956 to 1957. (Courtesy of the Evangeline Baseball League Collection, Archives and Special Collections, Nicholls State University, Thibodaux, Louisiana.)

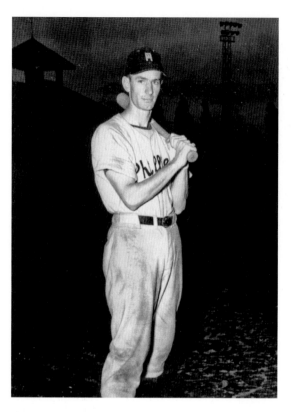

ROGERS H. MCKEE: THE NAME. The origin of Rogers's moniker makes for a marvelous baseball story. His father, Broadus, a passionate Cardinals fan, vowed during his wife's 1926 pregnancy that if the Cards won the pennant that year, he'd name a son after his favorite Red Bird. It is fitting that slugger McKee owns the same name as Rogers Hornsby, the man who posted the highest major league batting average for a single season, .424 in 1924. McKee is seen here as a member of the 1946 Terre Haute Phillies. (Courtesy of Rogers Hornsby McKee.)

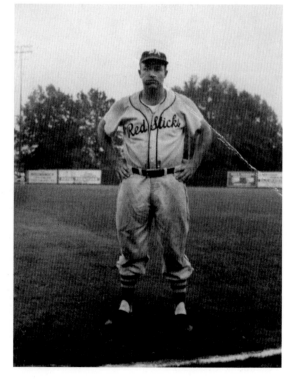

BILL DOSSEY. Dossey managed the Red Sticks to fourth place in 1955. The team finished the second half of the split season tied for second and completed the campaign with an overall record of 73-66. Dossey belted 20 home runs and pushed 101 runners across the plate that year. He led the league in 1954 when he batted .410 with Texas City/Thibodaux. Dossey is pictured in August 1955. (Courtesy of Evangeline Baseball League Collection, Archives and Special Collections, Nicholls State University, Thibodaux, Louisiana.)

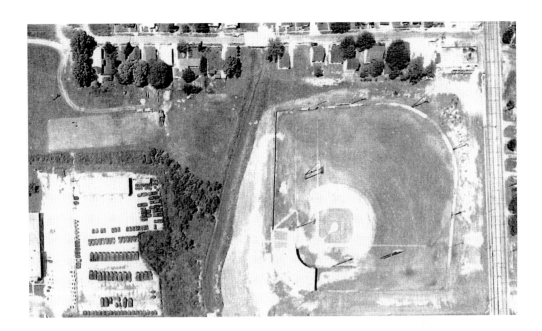

PETE GOLDSBY PARK. By the mid-1950s, age and a lack of parking deemed City Park Stadium inadequate. A new convenient stadium location was explored, and land off of Scenic Highway was acquired. Built between 1955 and 1956, Pete Goldsby Park saw its first Evangeline game on Opening Day, April 17, 1956. The Thibodaux Senators defeated the renamed Rebels 13-9. The park was formally dedicated later that summer on August 30. (Courtesy of Department of Public Works, Engineering Division, City of Baton Rouge.)

BLACKBALLED. This racially motivated hate mail addressed to Evangeline League president Ray Mullins illustrates the venom impacting the Vangy. Blacks had already been playing in the Evangeline circuit, but a 1956 Baton Rouge ordinance forbade integrated sports on city fields. The league would begin to crack when the Lake Charles Giants came to the capital with three black players. (Courtesy of the Evangeline Baseball League Collection, Archives and Special Collections, Nicholls State University, Thibodaux, Louisiana.)

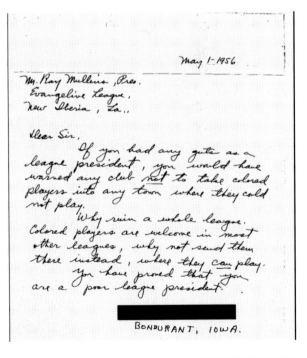

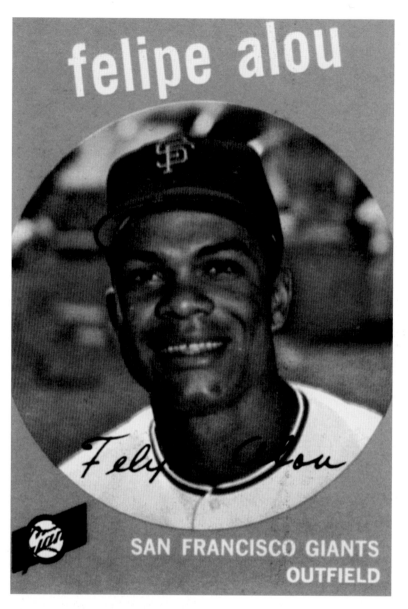

# felipe alou

**SAN FRANCISCO GIANTS**
**OUTFIELD**

GAME CALLED DUE TO INTOLERANCE. On January 17, 1956, the Baton Rouge Recreation and Parks Commission banned blacks from playing at soon-to-be-opened Pete Goldsby Park. The 1956 Lake Charles Giants had three black players, Felipe Alou, Ralph Crosby, and Charles Weatherspoon. When Lake Charles came to play Baton Rouge, these men had to sit in the bleachers reserved for African Americans. The Rebels benched two players to appease Lake Charles. The next night, Saturday, April 28, Ralph Crosby was listed in the lineup. The game was postponed and then forfeited to Lake Charles. Shortly thereafter, the Giants sent their black players out of Louisiana. Alou batted .380 and hit 21 homers with Cocoa Beach of the Florida State League. The future major-league manager is pictured here in 1958. (Courtesy of Topps Corporation.)

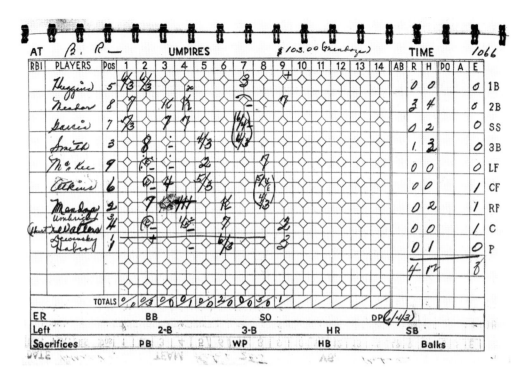

SECRET LANGUAGE OF SCORING. The official scorecard of June 26, 1956, shows Al Mendoza of Baton Rouge hit one of his three home runs that year in the fourth inning. Notations in the margin indicate that 1,066 fans passed the hat, providing Mendoza with $103 dollars. (Courtesy of Evangeline Baseball League Collection, Archives and Special Collections, Nicholls State University, Thibodaux, Louisiana.)

WHIP THE REBEL. Jovial Art Bertrand loved sports. He was a star pitcher (who played basketball and football as well) at Catholic High School. Nicknamed "Whip" because of his pitching delivery, Art tossed a number of one-hitters and two no-hitters at CHS. Donning a Rebels jersey, Whip went pro in 1956, winning one and losing four. Later in life, Whip became an avid painter. He passed away in 2005. (Courtesy of Whip Bertrand.)

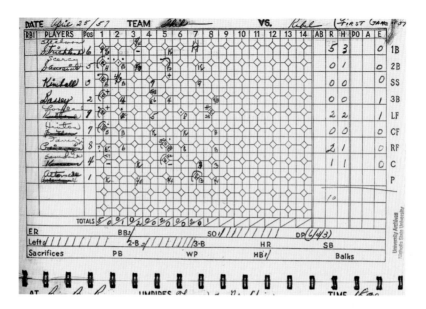

OPENING DAY 1957: BEGINNING OF THE END. Dwindling attendance doomed the Evangeline circuit in 1957. Technical innovations, like television and air conditioning surely had an impact on entertainment choices. The Baton Rouge Rebels and the Lafayette Oilers disbanded on June 20. (Courtesy of Evangeline Baseball League Collection, Archives and Special Collections, Nicholls State University, Thibodaux, Louisiana.)

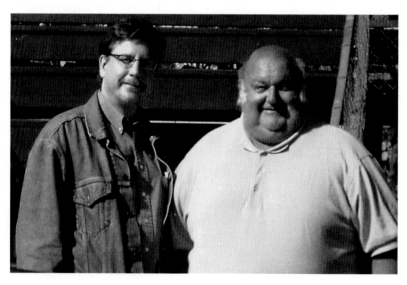

THE LEAGUE OF AN EXTRAORDINARY GENTLEMAN. Everyone knows Richard Pizzolatto as Coach Pizz. The Crowley resident and retired high school teacher/coach has dedicated his life to Cajun country baseball. He is now the driving force behind the annual Evangeline League reunion. Pizz (right) is pictured with author Michael Bielawa at Miller Stadium.

# THE LASTING LEGACY OF KIDS' CLINICS

Perhaps the one example that best personifies Baton Rouge as a baseball city is the amazing legacy of youth clinics. For decades, these free February camps offered children an opportunity to meet and learn from major-league players. Hank Aaron, Lou Brock, Dizzy Dean, Bill Dickey, Bob Feller, and Mel Ott, among others, have visited neighborhood ball fields to share their time and talent with youngsters.

Two wonderful organizations, the Baton Rouge Kids' Baseball Clinic and the Capital City Kids' Baseball Clinic were initiated for the benefit of children and to promote baseball. Each clinic began with the vision of very special individuals.

The Baton Rouge Kids' Baseball Clinic came about in 1947 through the efforts of baseball enthusiasts Tony John, Walker Cress, and John Fetzer. Initially sponsored by Esso (Tony John played with the company team), and then the Catholic Youth Organization (CYO), the clinic became independent soon after and has run continually up to the present day.

Willie Spooner was the inspiration behind the Capital City Kids' Clinic, incorporated in July 1955. Spooner's efforts brought Buck O'Neil, who in turn brought a very young Cubs shortstop by the name of Ernie Banks, to City Park Stadium the following February. This was the beginning of a clinic that ran for nearly two decades featuring many major-league superstars.

The dedicated Baton Rouge gentlemen responsible for bringing these clinics to reality, and the thoughtful instructors who participated in them, are a credit to the national pastime. Because of their efforts, Willie Spooner, Tony John, Walker Cress, and John Fetzer must each be considered baseball heroes.

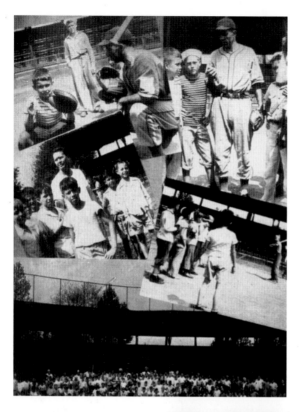

BASEBALL CAMPS BEGIN. In 1940 and 1941, Standard Oil held baseball camps for boys in Baton Rouge. World War II derailed such luxuries. The Esso baseball team began offering the program again after the war in 1946 for boys ages 7 through 12. These were practice sessions lasting from spring to summer. These shots were taken in March 1946 featuring scenes from the Esso-sponsored clinic at City Park Stadium. (Courtesy of ExxonMobil.)

THREE WISE MEN. While hunting with close friends during the winter of 1946, Tony John struck upon the idea of creating a free kids' baseball clinic in Baton Rouge featuring major leaguers. The inaugural clinic took place in February 1947. The three founders are pictured here at an early clinic: from left to right are John Fetzer, Walker Cress, and Tony John. Fetzer recalls a radio spot and a newspaper advertisement brought about 30 boys to the first clinic. (Courtesy of the DANA Corporation.)

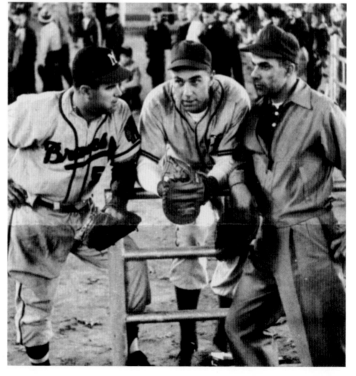

Mr. Baseball. Tony John loved baseball. He was an integral component of Standard Oil's top-notch semipro club during the late 1930s and 1940s. Tony also coached Catholic High School and American Legion baseball teams. He later scouted for his beloved Los Angeles Dodgers. Tony was the individual who conceived of free baseball clinics in Baton Rouge, taking the sport to a higher level of appreciation in the city. (Courtesy of ExxonMobil.)

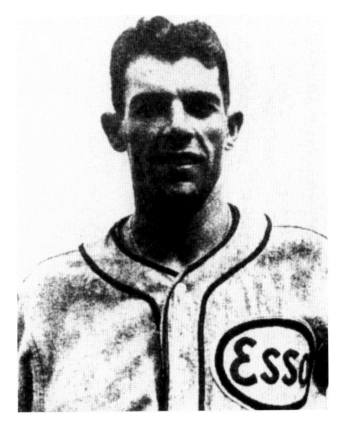

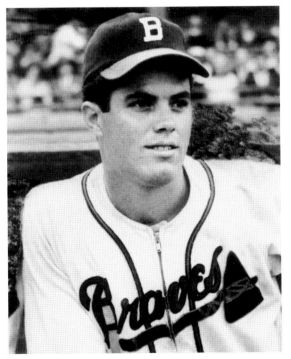

The Fantastic Fetzers. John Fetzer first met Tony John in 1944. Tony invited him to play third base for Esso after Fetzer shined for LSU. Fetzer was on the hunting trip with Walker Cress when Tony conceived of the clinic. Born in Shreveport in 1926, John Fetzer is part of a big baseball family. His brothers, Bob, Eddie and Donnie, saw success on local diamonds as well. John went on to pitch pro ball in the Boston Braves organization. (Courtesy John Fetzer.)

WALKER CRESS. Cincinnati Reds pitcher Walker James Cress (1917–1996) was a member of the triumvirate that brought baseball clinics to reality in Baton Rouge. He is pictured here at the clinic instructing Bob Bolin at City Park Stadium during the late 1940s. The former LSU Tiger (baseball and basketball) broke into the majors at the age of 31. His major-league career lasted from 1948 to 1949. (Courtesy of ExxonMobil.)

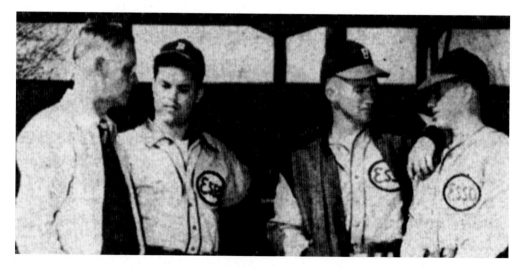

DOC WENDLER. This 1949 photograph shows, from left to right, Harold Wendler, John Fetzer, major league infielder and future World Series–winning manager Alvin Dark, and LSU freshman E. C. Hunt. "Doc" Wendler had lived in Baton Rouge since the beginning of the 1940s. He was the Dodgers trainer in Brooklyn as well as when the team moved to Los Angeles. Wendler was with Brooklyn in 1955 when "dem bums" defeated the Yankees, and he retired after Los Angeles defeated the Go-Go Sox in the 1959 World Series. (Courtesy of ExxonMobil.)

MEL AS MENTOR. Red Sox hurler Mel Parnell shares the secrets of pitching with Charlie Albritton during the 1949 clinic. Whatever Mel imparted upon this young pitcher had a lasting impression. Albritton would make national news three years later when he tossed a perfect game for Catholic High. Parnell matched Charlie four years after that with his own no-hitter against the White Sox. (Courtesy of ExxonMobil.)

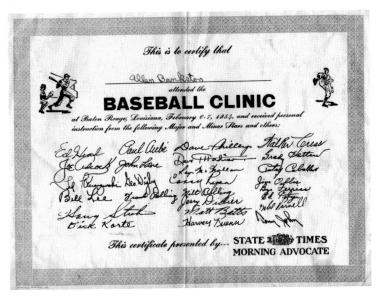

SHEEPSKIN FROM THE HORSEHIDE SCHOOL. Boys who participated in the February clinic received an official certificate. The document was issued by the Baton Rouge State-Times and Morning Advocate and featured facsimile autographs of the professional players and coaches participating in that particular year's camp.

THE ROSTER GROWS. By the early 1950s, an extensive array of professional athletes was taking part in the clinics. The once homegrown gathering now blossomed to bring players and coaches from across the country to Baton Rouge. This group photograph features the 1953 instructors from left to right: (first row) George Digby, Harold "Doc" Wendler, Dizzy Dean with his arm around Mel Ott, Matt Batts, Mel Parnell, and Bill Lee; (second row) Dickie Thompson, Joe Adcock, Boo Ferris, and Schoolboy Rowe; (third row) Ed Head, Milt Bolling, Roy McMillan, Grady Hatton, Ted Kluszewski, Dave Madison, and Walker Cress. (Courtesy of Archives Department, Diocese of Baton Rouge, Bishop Stanley Ott's personal papers, and Bob Waltman.)

THE LASTING LEGACY OF KIDS' CLINICS

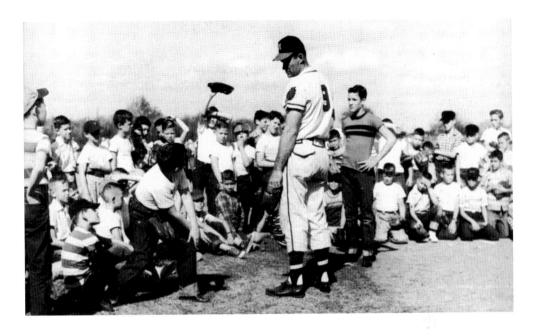

JOE ADCOCK COMES HOME. Louisiana native and LSU alumnus Joseph Wilbur Adcock, who lettered in 1947, consistently returned to Alex Box Stadium as a clinic instructor. A prolific power hitter, Joe is pictured here instructing a large group of boys about the footwork needed to patrol first base. This photograph was taken around 1962. (Courtesy of the DANA Corporation.)

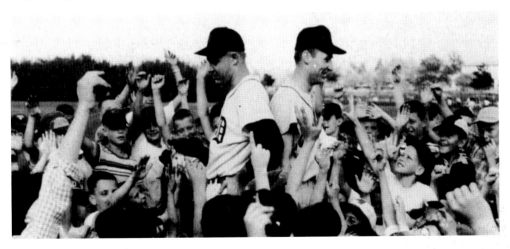

A SEA OF HANDS. Surrounded by eager children, Harvey Kuenn (left) and Frank Bolling of the Detroit Tigers field questions during a c. 1959 clinic. Kuenn was the 1953 Rookie of the Year and attained a .303 average during his 15-year career. Overcoming serious illness and the amputation of his right leg below the knee, Milwaukee coach Kuenn was named manager of the fifth-place Brewers in June 1982. Kuenn brought the club, nicknamed "Harvey's Wallbangers," all the way to the World Series. (Courtesy of the DANA Corporation.)

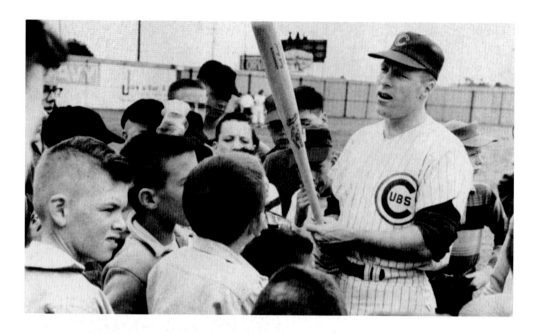

RICHIE ASBURN. Lifetime .308 hitter and future Hall of Fame outfielder Richie Asburn is seen here at the clinic in the early 1960s, when he was a member of the Chicago Cubs. The five-time All Star is giving some pointers on the art of hitting to a group of attendees. Note the lad pictured in the lower left sporting a future fashion statement. (Courtesy of the DANA Corporation.)

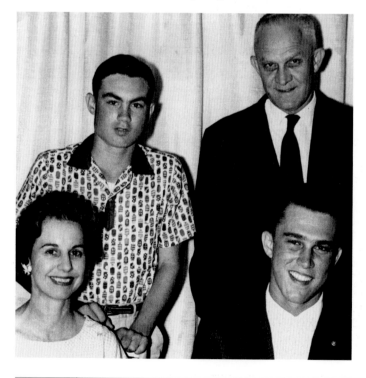

FROM THE CLINIC TO THE MAJORS. Dalton Jones was one of the first clinic attendees to become a major leaguer. He began attending the clinic about 1950. This photograph was taken the night he signed with the Boston Red Sox. His mom, Louise, is seated next to Dalton. Dalton's brother, Melvin, and their father, Clinton, are standing. Mel was a very good infielder as well at Istrouma High School. (Courtesy of Dalton Jones.)

CAPITOL CITY KIDS' BASEBALL CLINIC.
In 1955, McKinley High School coach
Willie Spooner helped incorporate Baton
Rouge's first baseball clinic for African
American children. Over the next
several years, Spooner would assemble a
long list of outstanding pro ball players
at City Park Stadium and Pete Goldsby
Field. Instructors included Billy Williams,
Curt Flood, Tommie Aggie, Ed Charles,
and Big Earl Wilson. By 1966, 5,000
children ages 8–18 were taking part in
Willie Spooner's dream. (Courtesy of
Willie Spooner.)

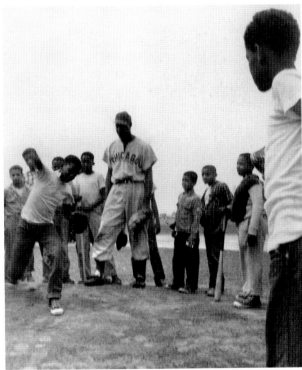

BRINGING IT. When Willie
Spooner initially conceived of
a clinic to help local African
American kids, he contacted
sports enthusiast William Breda.
In turn, Breda called major-league
players he knew. Former Kansas
City Monarch Buck O'Neil
watches a boy's mechanics as
a group of kids look on during
the first clinic in 1956. When
the Cubs named Buck O'Neil
a coach in 1962, he became
the first African American in
major-league history to hold the
position. (Courtesy of the Buck
O'Neil Collection, Negro Leagues
Baseball Museum, Inc.)

MR. CUB AND THE PRESIDENTS. This photograph taken at Reddy Street School during the 1956 clinic features, from left to right, Pres. Felton G. Clark of Southern University, Pres. Ralph Waldo Emerson Jones of Grambling State University, 25-year-old future Hall of Fame Cubs shortstop Ernie Banks, and Buck O'Neil. Banks and O'Neil were the first major-league instructors involved with the Capital City Kids' clinic. (Courtesy of the Buck O'Neil Collection, Negro Leagues Baseball Museum, Inc.)

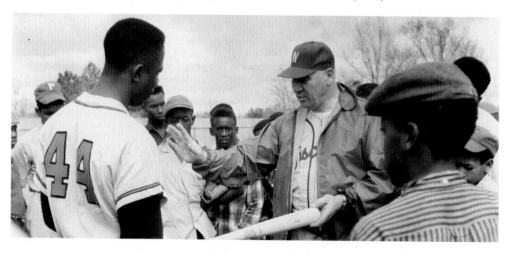

HAMMERIN' HANK. The man wearing number 44 is unmistakable. Home run champion and Capital City Kids' clinic instructor Hank Aaron is pictured here in Baton Rouge about 1967. Assisting in the instruction is Art "Dynie" Mansfield. Captain of the 1929 University of Wisconsin baseball team, he served as head coach at UW from 1940 to 1970. Willie Spooner became a friend of Art's, having received his master's degree from UW in physical education. (Courtesy of Willie Spooner.)

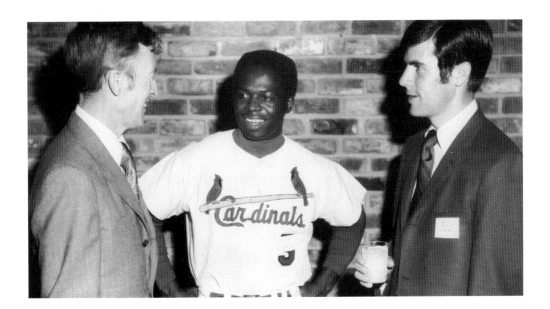

LOU BROCK. Capital City Kids supporters gather in 1971. Lou Carter (left) of WXOK Radio is talking with former Southern University Jaguar and base-stealing phenom Lou Brock of the St. Louis Cardinals. The clinic instructor would be elected to the Baseball Hall of Fame in 1985. On the right, Dennis English, a representative from Kaiser Aluminum, joins in the conversation. (Courtesy of Willie Spooner.)

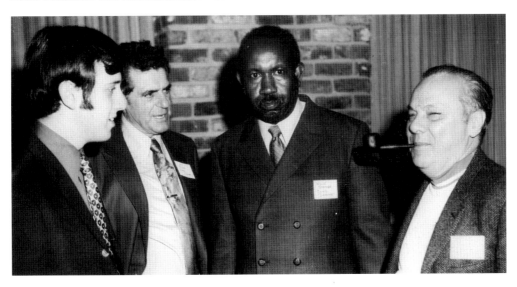

CLINIC CIRCLE. Clinic sponsor Joe Romano (second from left), owner of Romano's grocery on North Boulevard, is pictured here in 1971. Clinic director Willie Spooner stands second from the right. *Advocate* sports editor Vesta "Bud" Montet strikes a familiar pose with his pipe. Montet's journalism career spanned six decades. He was a vociferous proponent of baseball in the city. Bud passed away in 1999. (Courtesy of Willie Spooner.)

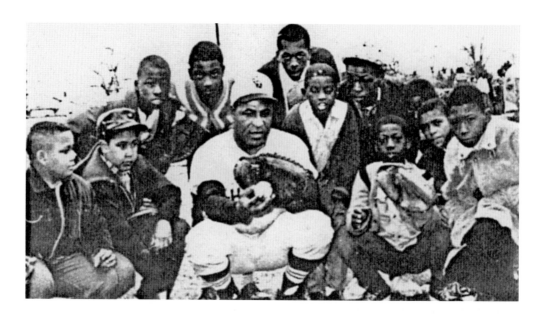

CALLING THE PITCHES. Veteran White Sox scout Sam Hairston was an instructor with the clinic beginning in the 1960s. He was the first black player born in America signed by the White Sox. The determined fellow to Sam's left came to the clinic prepared. Sam was an outstanding teacher. His sons John (who attended Southern) and Jerry both played major-league ball. (Courtesy of Willie Spooner.)

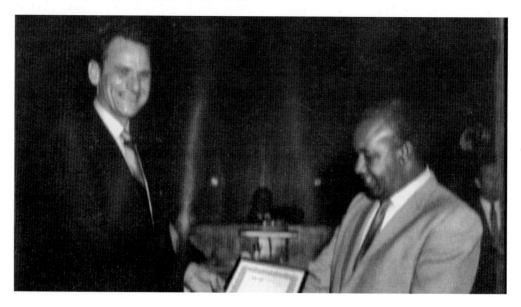

ALL SMILES. In 1972, the Baton Rouge City Council recognized Willie Spooner with an award honoring his dedication and efforts in creating the Capital City Kids' Baseball Clinic. Council member V. M. "Lank" Corsentino (left) makes the presentation to Willie in the council chambers. (Courtesy of Willie Spooner.)

THE LASTING LEGACY OF KIDS' CLINICS

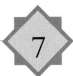

7

# Baton Rouge's
# Boys of Summer

Sportswriter Thomas Boswell said, "Of all American sports, none can match baseball's passion for the past." Here the journalist touches on the notion of how baseball fans enjoy comparing and debating former and present teams and players. But this statement has perhaps a deeper meaning. Baseball draws us back to our own past with a passion. This chapter takes a look at those childhood memories.

Major leaguer David Dellucci played Little League ball in Baton Rouge. Fans always ask if the game is any different compared to when he was growing up. David tells them, "I still am playing a kids game. The only difference is that I'm now getting paid and there are more people in the stands. Otherwise there is no difference."

Baton Rouge has always been brimming with young players and teams and leagues, whether it was a gang getting together in the late 1940s for a game at Bogan's Pasture or the Atkinson brothers in their backyard improving their batting skills by pitching and hitting mayonnaise lids in a homespun game they dubbed "lids." Community-minded businesses sponsored American Legion ball that became part of the city's fabric as far back as the 1930s and continued producing a bevy of top-notch clubs throughout the 1950s and beyond. Healthy baseball rivalries blossomed between Catholic High, Istrouma, and Baton Rouge High School. In the 1970s, kids were selected for teams that represented local parks and competed against each other. All these players and teams and leagues foster a beautiful passion.

CRESCENT LAUNDRY. Here are the 1935 American Legion victors for Baton Rouge. Roe Frank Cangelosi managed the Highland Road business. From left to right are (first row) mascot Junior Nolan, bat boy Allen Boudreaux, and mascot Merion Cangelosi; (second row) M. Griffith, Nelson Cannon, Ray Dicharry, J. E. LaBauve, J. J. Copponex, and T. J. Bankston; (third row) trainer Mario Termini, V. J. Gianelloni, Maurice Rogers, Ralph Dupuy, A. J. Orillion, and Clayton Landry; (fourth row) scorer George Abraham, sponsor Roe Cangelosi, assistant coach Tony Giganti, E. J. Daigle, P. Fasuillo, Jim Wall, coach Dr. Joe Nolan, and principal of Catholic High School Brother Peter Basso. (Courtesy of Foundation for Historical Louisiana Photograph Collection.)

PROPHETIC PHOTOGRAPH. Dalton Jones was born December 10, 1943. He was about seven years old when he posed in his Red Sox uniform in the backyard of his Delaware Street home. His childhood hero was Ted Williams, and he loved the Red Sox. Dalton's father, Clint, played pepper with his son every evening when he got home from the refinery. Dalton recalls, "When we played my dad asked, 'If you ever stop loving baseball, just tell me. I love hunting and fishing too. I only want us together doing what makes us happy.'" Dalton was certain he would make it to the majors. He announced to Mrs. Satterwhite, his fourth-grade teacher at Winbourne Elementary School, "I'm going to be a major league baseball player!" Boyhood dreams do come true. Jones was a member of the Red Sox's 1967 Impossible Dream team. The little boy from Delaware Street grew up to bat .389 in the World Series that year. (Courtesy of Dalton Jones.)

BOGAN'S PASTURE GANG. This August 1948 photograph was taken at the field known as Bogan's Pasture, located off Plank Road near the present-day Capital High School. Those identified here include (kneeling from left to right) Antime "Teemie" Landry, Al Ackman, three unidentified, Dove McTaggert, and Charlie Albritton; (standing) W. K. Henigan, two unidentified, Edgar Ruiz, unidentified, Cooter Zimmerle, Donnie Harrel, Whip Bertrand, and Scotty White. (Courtesy of Whip Bertrand.)

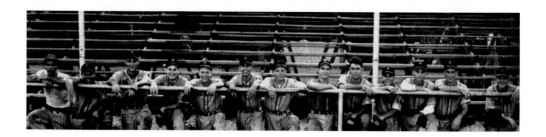

THE BEARS TAKE TEXAS. In the summer of 1948, Catholic High's Golden Bears, traveled to Texas to participate in the invitational Houston Junior Chamber of Commerce tournament. The exceptional squad under coach Tony John took the championship. This photograph features some of Baton Rouge's well-known baseball families. From left to right are Tony John, Jerry Marchand, Joe Modicut, Eddie Fetzer, Gerald Didier, Malcolm Landry, Arthur Gautreaux, Luther Payer, Bill Conway, Lou Simonneaux, Bobby Fetzer, Bill Segura, and Joe Songy. (Courtesy of ExxonMobil.)

THOSE FABULOUS FETZER BOYS. The Fetzers are a big baseball family. In 1949, 11-year-old Donnie Fetzer played C-League ball (for ages 9–12) in the American Legion's junior program. He was the backstop for the Moran Motors Company. The team finished its season in second place in a 12-team league. Donnie was selected for the All Star squad and was also the batboy for the Esso Oilers. (Courtesy of ExxonMobil.)

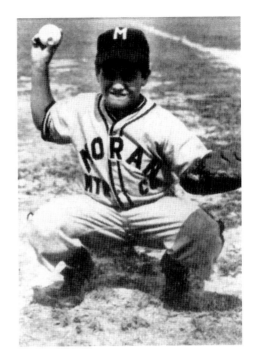

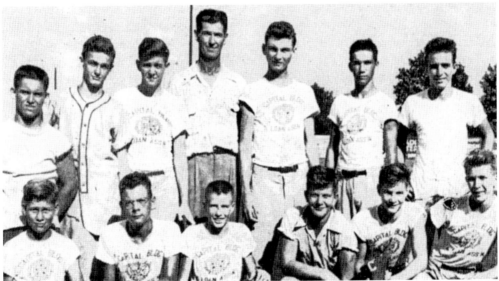

THIRD PLACE IN 1948, SECOND IN 1949, AND TOPS IN 1950. Dedication made this squad city champs. The Capital Building and Loan Association American Legion B-Class team, for boys 14–15 years old, are pictured here from left to right: (first row) Donnie Leopard, Jack Lockhart, Gayle Nix, Garry Minton, Gerald Purvis, and Auburn Bryant; (second row) Rocky Stafford, Tommy Routon, Stanley Pipes, coach Clyde Leopard, Jerry Vick, Jimmy Brown, and Clifford Ourso Jr. Not pictured are Adrian Amrhein and Denny Sutton. (Courtesy of ExxonMobil.)

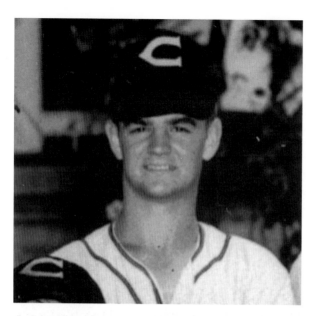

CHARLIE PERFECTO. Charles Albritton's pitching feat of April 26, 1952, splashed across the nation's sports pages the next morning. The Catholic High School left-hander tossed a perfect game. In the process, Charlie struck out seven Plaquemine High School batters on his way to a 5-0 victory at City Park. The game ended on a somersaulting grab by second baseman Robert Songy in short right-center field. (Courtesy of Whip Bertrand.)

AN EASY GAME TO SCORE. This is the page from the official score book used during Charlie Albritton's 1952 perfect game. A regulation high school contest is seven innings, so the scorer entered 21 consecutive outs for the Plaquemine High nine. Catholic High's coach, Mel Didier, remembers praying for Charlie with each pitch once the bench became aware of the gem unfolding in front of their eyes. (Courtesy of Whip Bertrand.)

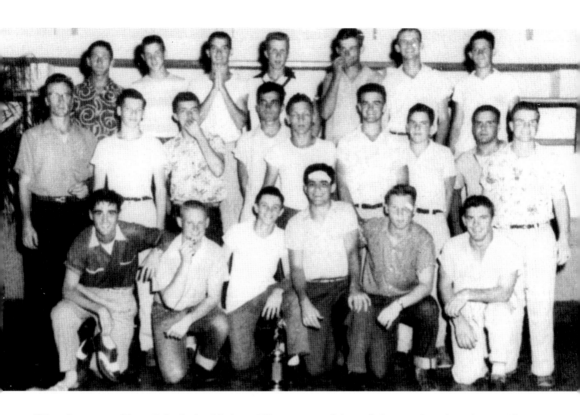

"THE GREATEST TEAM." Catholic High's 1953 coach, Mel Didier, recognizes talent. He would one day become a professional scout and later serve as director of Scouting and Player Development for Montreal and Seattle. Didier judges that this Bears team, which won CHS's first state championship, is one of the "greatest high school teams" in American history: "Four of these players signed pro contracts, three of them right out of high school, and another seven received college baseball scholarships." This shot of the brand-new champions was taken at Catholic High just after the team returned from defeating Ouachita 2-0 at Alex Box Stadium for the championship. Pictured from left to right are (first row) A. Ackman, J. Miller, R. Bryan, D. Fetzer, J. Zimmerle, and M. Millet; (second row) Coach Mel Didier, R. Hernandez, W. Barfield, T. Barfield, W. Bourdier, C. Albritton, Copper Harrell (manager), Ed Ruiz, and R. Songy; (third row) N. Millet, C. J. Payne, W. McGraw, Auburn Bryant, D. R. Atkinson, A. Bertrand, and H. Hoover (manager). (Courtesy of Catholic High School.)

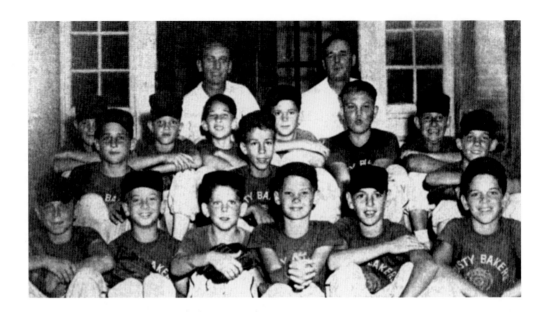

SMILING VICTORS. The 1957 Tasty Bakers American Legion D-Class baseball champions included, from left to right, (first row) Randy Reed, Len Gremillion, Bob McGuire, Frank Hatcher, Doug Drumright, and Jim Bollinger; (second row) Doug Moreau, Verne Dicharry, and Bob Turner; (third row) Doug Woolfolk, Ned Woolfolk, Bob Nolan Jr., Pat Price, Charles Henry, and Leroy Mouton; (fourth row) Bob Nolan Sr. and V. J. Dicharry. Not pictured are Win Dyer, Bryan Frye, John Fuqua, and Paul Spaht. (Courtesy of ExxonMobil.)

WHERE THERE WAS BASEBALL, THERE WAS CLINTON JONES. Longtime Esso employee Clinton Jones coached both the B- and D-Class American Legion teams of 1958. Bob Duncan and Joe LaBauve assisted Jones with the champion B division team, which includes, from left to right, (first row) Dalton Jones (barely visible), Ken Russell, Bob Duncan, Robert Sumrall, John L. Sullivan, and Lamar LaBauve. (Courtesy of ExxonMobil.)

NEW DECADE, NEW CHAMPIONS: ISTROUMA HIGH. The Indians fielded a memorable team during 1959–1960. Istrouma won 18 games while losing only 7 before taking two out of three from De LaSalle in the state championship. In 1961, Istrouma again advanced to the state championship round but were defeated by Jesuit High. The New Orleans school was led by a redheaded first baseman named Rusty Staub. (Courtesy of Istrouma High School Library.)

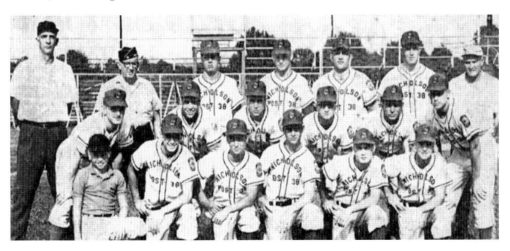

CLINTON JONES'S CROWNING ACHIEVEMENT. For years, Clinton Jones lent his time and talent to help instruct the youth of Baton Rouge. His son Dalton observes, "This team was the crowning achievement of my father's baseball life. Over the years he coached these players as little boys all the way through to this state championship team." This is the 1963 Nicholson Post 38 Welsh Funeral Home team that won the Louisiana American Legion championship. This was Baton Rouge's first Legion team to win the state title. (Courtesy of Capital City Press, *Baton Rouge Advocate*.)

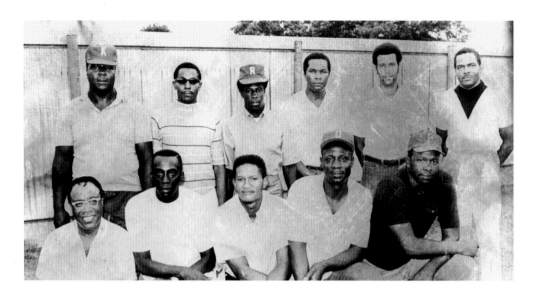

BATON ROUGE LITTLE LEAGUE AND PONY LEAGUE COACHES. This c. 1970 photograph shows baseball coaches and team sponsors from across the community. From left to right are (first row) Dr. C. J. Gillian (Gillians), Robert Knighten (Scott's Bluff Morticians), Robert Smith (Grays), Lee Martin (Dunn's Frezo), and Alfred Cummings (City Police); (second row) Jerry Johnson (First Federal Savings), Milton Lee (Zachary Men's Club), Charlie Williams (Romano's Pack and Save), Albert Thomas (Jet Reds), Milton Gray (Scott's Bluff Morticians), and Herman Spikes (St. Francis Xavier). (Courtesy of Willie Spooner. Identification by Willie Spooner and Nathaniel Mills.)

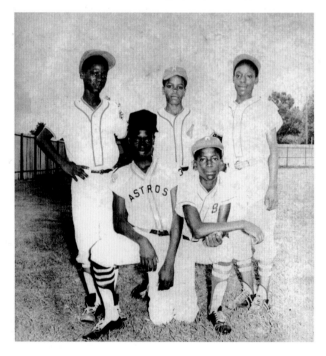

EASTERN DIVISION LITTLE LEAGUE. This photograph was probably taken sometime in the 1970s. Players are listed with their team sponsors. From left to right are (kneeling) Wilbert Jordan (Purple Shield Funeral Home) and Elgin Stewart (Cawsc); (standing) Clifford W. Martin (Dunn's Frezo), Glenn McKinney (Romano's Pack and Save), and Anthony Martin (Dunn's Frezo). (Courtesy of Willie Spooner. Identification by Willie Spooner and Nathaniel Mills.)

# 8

# PRO BALL RETURNS

Following an absence of 19 years, professional ball returned to Louisiana's capital during the nation's bicentennial. The Baton Rouge Cougars of the new independent Gulf States League made their debut in 1976. The city continued its tradition of hosting a minor-league club unaffiliated with major-league organizations. Home games were played at Alex Box Stadium. Except for Baton Rouge, the five other clubs were all located in Texas. Despite the Cougars' exciting playing—they won both halves of the season—the league barely lasted its sole year of existence. Poor money management on both the local and league level was blamed for the independent league's demise.

At the turn of the century, the 2001 Blue Marlins represented Baton Rouge in the newly formed All-American Association. Baton Rouge was crowned champion, but once again, this league lasted only a single season. Scott Bethea managed the talented Blue Marlins. The general manager was Lydia Bergeron, who had also served in the front offices of the Lafayette Bayou Bullfrogs, Alexandria Aces, and Windy City Thunderbolts. Teams abandoning the All-American Association caused its collapse.

The Southeastern League of Professional Baseball (SLPB) was inaugurated in June 2002. The Baton Rouge River Bats called Pete Goldsby Field home for two seasons, 2002 and 2003. Since 1996, L. J. Dupuy has made it a priority to renovate the stadium (constructed in 1956). The River Bats played competitive baseball, but low attendance and financial difficulties across the league proved an insurmountable obstacle. The SLPB folded in March 2004.

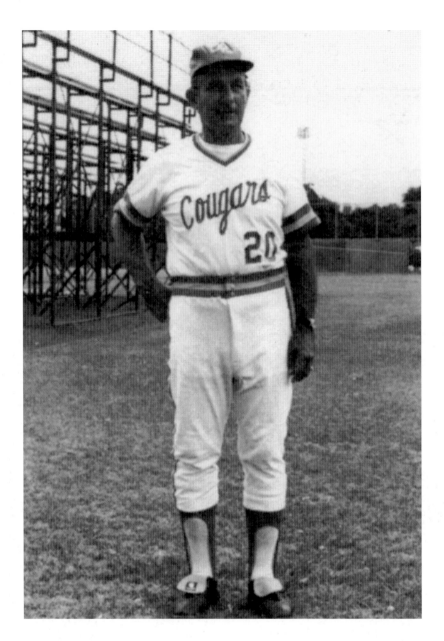

COUGAR WITH A HEART. A major-league catcher for 10 seasons, Matt Batts was a teammate of Ted Williams, Bobby Doerr, Dom DiMaggio, and Mel Parnell. He and his wife moved to Baton Rouge in 1953 because of their work with the Kids' Baseball Clinic. As manager of the 1976 Cougars, he looks back on his team with great respect: "The Cougars were a damn good ball club and a good league too!" The one regret Matt has is that the Cougars and league didn't last. "Ownership stopped providing money. Hell, we had to run the ball club on our own the last two weeks! I paid out of pocket to keep the team going. And finally when things were breaking up I paid the way for most of my boys to get back home." (Courtesy of Mike Aronstein.)

COUGARS PROGRAM COVER. During the Baton Rouge Cougars' single season of existence in 1976, home games were played at Alex Box Stadium. The team completed the first half of the split season on top of their East Division with a record of 25 wins and 17 losses. With just two weeks left to play in the second half, and the Cougars in first place with an 18-10 mark, the bankrupt franchise withdrew from the league on August 13. (Courtesy of Marc Palmer.)

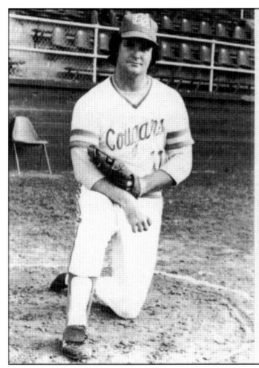

GUMBO AND ALASKA STREET MEMORIES. Terry Leach posted a 1-0 record with the Cougars, his first pro team. His sidearm would bring him World Series rings with the 1986 Mets and the 1991 Twins. Terry reminisces in his autobiography, *Things Happen for a Reason*, that the Cougars had a "blast" while in Baton Rouge. He lived on Alaska Street and couldn't get enough of the delicious gumbo at Piccadilly Cafeteria. (Left courtesy of Mike Aronstein; right courtesy of Topps Company.)

OLD MAN ROOKIE. Tom Brown was the Cougars' crafty ace. He led the team with a 9-1 record and the league with a 1.51 ERA. After the Cougars, Tom focused on his job as junior high athletic director in Baton Rouge. Seattle Mariner scout Mel Didier convinced him to return to pro ball. In 1978, at age 29, Tom appeared in six major-league games with the Mariners. He was LSU's pitching coach from 1985 to 1986. (Courtesy of Mike Aronstein.)

"IT WAS A WILD YEAR." During 1976, Marc Palmer joined the club on their last tour: "It was a wild year. When their regular equipment guy didn't show, the team asked me to go to Texas. They drove in two borrowed vans and one of them was a daycare van. I became their batboy, and for a 16 year old, well it's still a thrill to look back on." This is the booster pin Marc was given as a season-ticket holder. (Courtesy of Marc Palmer.)

PRO BALL RETURNS

MISS LYDIA AND THE BLUE MARLINS, 2001. Lifelong Mets fan Lydia Bergeron was general manager of the Baton Rouge Blue Marlins. She began her pro baseball career as assistant general manager of the Lafayette Bullfrogs in 1997 before accepting the key role with Baton Rouge. At season's end, the Abbeville native was named 2001 Bowie Kuhn Executive of the Year by the All-American Association of Professional Baseball Clubs. (Courtesy of Lydia S. Bergeron.)

BIG AND LITTLE LEAGUE. Player/manager Scott Bethea emerges from the dugout at Pete Goldsby Field with one of the Little Leaguers taking part in the Blue Marlins "Field of Dreams" program. Bethea played second and third base for the Blue Marlins, batted .346, and piloted Baton Rouge to first place. He was deservedly named 2001 Manager of the Year in the All-American Association. (Courtesy of Lydia S. Bergeron.)

COACHING LEGENDS. LSU's former head baseball coach, J. Stanley "Skip" Bertman (left), and Southern University's head baseball coach, Roger Cador, pose with Gill, the mascot for the Blue Marlins at Pete Goldsby Field. Bertman and Cador are among the greatest collegian baseball coaches of all time. (Courtesy of Lydia S. Bergeron.)

BITTERSWEET BLUE MARLINS. The 2001 Baton Rouge club won the first, and only, pennant in the history of the six-team independent All-American Association. After capturing first place with a record of 44-28, the Blue Marlins took three of five games from the Albany Alligators in the championship series. Despite the squad's on-field success, owner Bruce Constantin was obliged to surrender the franchise in early 2002 due to financial considerations. (Courtesy of Lydia S. Bergeron.)

BATON ROUGE RIVER BATS 2002. This is the inaugural River Bats team of the Southeastern League. Home games were played at Pete Goldsby Field. They finished just a game out of first with a 39-29 record. Club owners were L. J. Dupuy, (second row far right, wearing number 30, who also served as general manager); his sister, Col. Bonnie J. Robison (U.S. Marine Corps); and Col. Gilda Jackson (retired, U.S. Marine Corps). Mascot River Bat Man (also known as Troy Morgan) kneels on the far left. The league lasted through the 2003 season. (Courtesy of Debbie Dupuy.)

NUMBER 5, CHRIS CASSELS. Chris was the player/manager for the 2002 River Bats. He played ball in the Milwaukee Brewers and Montreal Expos systems before beginning his independent ball career. He led the River Bats to a second-place finish one game behind the Pensacola Pelicans. He batted .298 as a River Bats designated hitter during 2002. (Courtesy of Stephanie Smith.)

WILLIAMS THE CONQUER. Jason Williams was a member of the 1993 and 1996 LSU College World Series victors. Returning to Baton Rouge after five years in the Cincinnati Reds organization, he batted .376 for the 2001 Blue Marlins and was named MVP of the All-American Association. He completed his pro ball career with the River Bats, batting .319 in 2002 and .346 in 2003. (Courtesy of Jason and Christine Williams.)

MIGUEL MARICHAL. Born in the Dominican Republic, the rookie pitcher is the nephew of Hall of Fame pitcher Juan Marichal. In 2003 with the River Bats, Miguel won five while losing five. He struck out 43 batters, while walking only 18, in 60.1 innings. Miguel is posing with big-time Baton Rouge baseball fan Stephanie Smith. Each season, Stephanie and her friends handcraft an assortment of home jerseys featuring the numbers of favorite players. (Courtesy of Stephanie Smith.)

A SPECIAL PERSON FOR BATON ROUGE. John Henry Williams, son of Hall of Famer Ted Williams, joined the River Bats in July 2003. General manager L. J. Dupuy remembers John's unwavering work ethic about batting practice. But he was also caring. When a teammate broke his arm, John visited the outfielder in the hospital, offering the family any assistance he could. John Henry died of leukemia eight months after joining the team at the age of 35. (Courtesy of Leatus Still.)

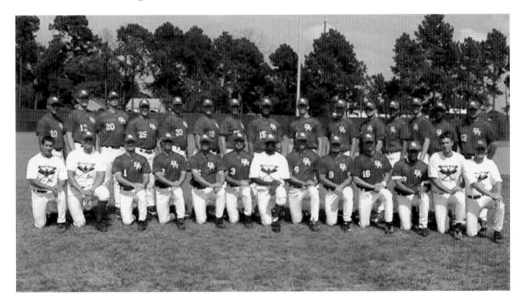

ANOTHER BATON ROUGE CHAMPIONSHIP. The 2003 standings ended with the top three teams finishing just as they did a year before. This Baton Rouge squad dominated in the postseason. In the championship round, the River Bats won three games to one over first-place Pensacola and were crowned SLPB champs. (Courtesy of Debbie Dupuy.)

BASEBALL IN BATON ROUGE

HEART AND SOUL OF BATON ROUGE BASEBALL. L. J. Dupuy's lifelong dedication to baseball has impacted every level of the game in Baton Rouge. Born January 24, 1944, he played baseball with Brusly High School and attended Southeastern Louisiana University on a basketball scholarship. From 1965 to 1966, he coached semipro in the capital area and from the late 1960s to 1995 coached American Legion ball. About a dozen of his players went on to play professionally. In the mid-1990s, Dupuy was president of the Baton Rouge Kids' Baseball Clinic. Beginning in 1996, L. J. coached and later managed the Prairie League's Brandon Grey Owls. Returning home, he served as hitting instructor for the Lafayette Bayou Bullfrogs. Dupuy is the driving force behind the Pete Goldsby Stadium renovations, and in 2001, the Blue Marlins named him coach. During 2002–2003, he was founder, co-owner, general manager, and coach of the Southeastern League's River Bats. In 2006, L. J. pilots the Baton Rouge Community College Bears. Over the last century and a half, Baton Rouge has been fortunate to have special baseball visionaries and leaders. Entering the 21st century, L. J. Dupuy is that grand old man of Baton Rouge baseball. (Courtesy of Debbie Dupuy.)

# TIGERS AND JAGUARS AND BEARS

Baton Rouge has been graced with college baseball—great college baseball. Louisiana State University and Southern University have continually placed exciting teams on local diamonds. Baton Rouge Community College, which just got their program underway in 2005, will certainly add to the capital's legacy of being an outstanding baseball town.

More than a century of college baseball provides a lot to look back on. Baton Rouge has bred winning teams since Harry Rabenhorst's 27 years as head baseball coach. His 1939 Tigers won LSU's first SEC championship. Red Swanson, Ray Didier, and Jim Smith continued the tradition, occasionally coaching SEC winners as well. During the Skip Bertman era, LSU compiled a record of 870 wins, 330 losses, and 3 ties. Warren Morris's bottom-of-the-ninth, game-winning home run during the 1996 College World Series has got to be one of the most dramatic hits in CWS history. Southern's coach Robert H. Lee brought the Jaguars to a championship in 1959, featuring future Hall of Fame member Lou Brock. More recently, Rickie Weeks of the Jags earned All-American honors as well as being selected to the USA National team.

This chapter looks at the earliest days, unique personalities, and just a few of the extraordinary memories associated with the capital's college baseball scene.

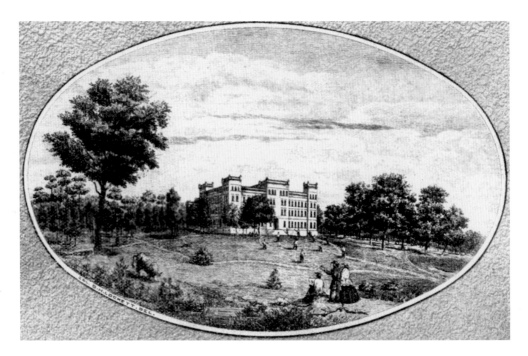

EARLIEST IMAGE OF LSU BASEBALL. This 1868 lithograph by Prof. Samuel Lockett depicts Louisiana State University's first home in Pineville. The illustration highlights an apparent cadet baseball game. From these humble origins, Tigers baseball would evolve into one of the nation's most successful sports programs. (Courtesy of LSU Photograph Collection, RG#A5000, Louisiana State University Archives, LSU Libraries, Baton Rouge.)

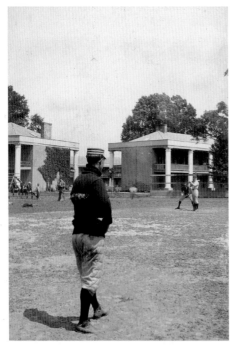

GAME ONE: START YOUR TAILGATING. Although LSU had been playing Tulane as far back 1888, the first official LSU intercollegiate baseball game took place in Baton Rouge on Saturday, May 13, 1893. The Tigers beat visiting Tulane 10-8. The *Daily Advocate* reported, "Few games have been prettier or apparently more evenly matched." This was the only game scheduled that year, but of long-term significance, team captain E. B. Young selected the squad's colors: gold and purple. The campus diamond was situated immediately south of the downtown Pentagon Barracks, visible behind the batter. (Courtesy of Andrew D. Lytle Collection, Mss. 893, 1254, Louisiana and Lower Mississippi Valley Collections, LSU Libraries, Baton Rouge.)

TIGERS AND JAGUARS AND BEARS

THE FIRST TIGER TO MAKE IT TO THE MAJORS. Roland Boatner Howell has the distinction of being the first LSU Tiger to play in the major leagues. Born January 3, 1892, in Napoleonville, Louisiana, the 20-year-old Howell debuted with the St. Louis Cardinals on Flag Day 1912. Billiken, as he was nicknamed, stepped to the mound three games that June, pitching a total of 1.2 innings while surrendering 5 hits, 5 earned runs, and 5 walks. (Courtesy of LSU Libraries' Special Collections, Baton Rouge.)

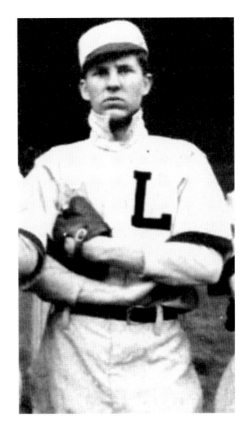

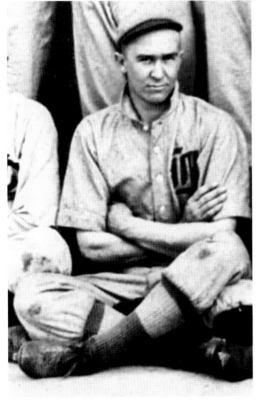

JOHN MERCER. Mercer was the second Tiger to play in the majors. He participated in a single game, on June 25, 1912, playing first base for the St. Louis Cardinals in what was actually Roland Howell's final major-league appearance. Attaining the wish that Moonlight Graham longs for in the film *Field of Dreams*, Mercer did get a chance to step to the plate. In his one at-bat, he went hitless. (Courtesy of LSU Libraries' Special Collections, Baton Rouge.)

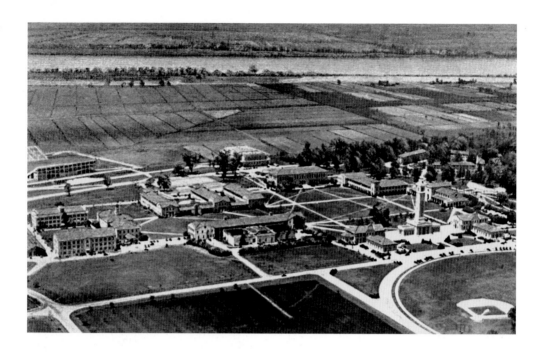

ROARING TWENTIES HEAR THE TIGER ROAR. This view shows the parade ground and ball field where LSU home games were played from the late 1920s until the mid-1930s. A dirt path is visible from home plate to the pitching mound, known as the "keyhole" design, popular at the time.

CLOSE BEFORE STRIKING (OUT). "General" Bill Lee of Plaquemine groomed his diamond talents in the shade of LSU's campanile in the late 1920s. Signed by the St. Louis Cardinals to a minor-league contract after his sophomore year, Big Bill later led the 1938 Cubs to the World Series. The Diamond Match Company sold matchbooks portraying movie stars and sports figures during the mid-1930s. General Lee is featured on this 1937 match cover. (Courtesy of the Michael Bielawa Baseball Collection.)

LSU's Real Roy Hobbs. Bama Rowell attended LSU on a football scholarship. Later as a major leaguer visiting Ebbets Field with the Boston Braves on May 30, 1946, he launched a fly ball that struck the Bulova Clock atop the scoreboard. "Bama's blast shattered the face of the clock, raining glass down on Dodgers right fielder Dixie Walker," according to "Inside Pitch," the free weekly e-mail newsletter from the National Baseball Hall of Fame and Museum in Cooperstown, New York. The scene so inspired Bernard Malamud, who was in attendance, that he incorporated it in his book, *The Natural*. (Courtesy of the National Baseball Hall of Fame Library, Cooperstown, New York.)

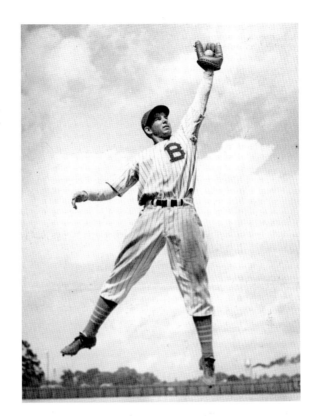

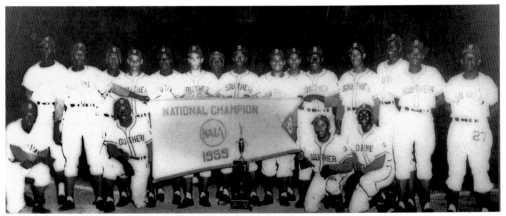

Southern University Champs. On June 7, 1959, the Southern University Jaguars defeated Omaha University 10-2 in Alpine, Texas, to claim the National Athletic Intercollegiate Association Baseball Championship for small colleges. SU also won the Southwest Athletic Conference Baseball championship that same year. From left to right are (kneeling) future Hall of Famer Lou Brock, R. Williams, A. Woods, and H. Triplett; (standing) H. Rhodes, J. Herman, Coach Hines, Wiley, A. Jackson, MacVea, unidentified, H. James, Roy McGriff, P. Lewis, H. Green, A. Johnson, E. Sam, team captain H. Levy, and Coach Lee. (Courtesy of Roy McGriff.)

A CLASS ACT: ROGER CADOR. Coach Cador played in the Atlanta Braves organization before being named Southern University's assistant baseball coach. Roger became Jaguars head coach in 1985. Since then, he has received seven Southwestern Athletic Conference Coach of the Year awards, and the Jags have won 10 conference championships. In 1987, Cador became the first coach of a historically black university to win a game in the NCAA tournament. But he feels his greatest accomplishment is "helping and growing with" Southern's exceptional students. (Courtesy of Norma Brown, Media Relations/Institutional Advancement, Southern University and A&M College.)

THE MAN WHO GIVES HIS ALL. Between 1984 and 2001, J. Stanley "Skip" Bertman became LSU's all-time winningest coach. Skip was named six times as National Coach of the Year, piloted the 1996 U.S. Olympic team, and won five national championships with the Tigers. *Baseball America* recognized him as the second greatest college baseball coach of the 20th century. Beyond these honors, Skip should be looked upon as a man who dedicated his vision, energy, and life to LSU and this city. (Courtesy of LSU Libraries' Special Collections, Baton Rouge.)

TIGERS AND JAGUARS AND BEARS

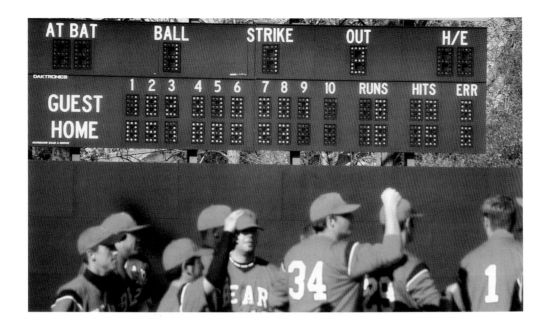

HERE COME THE BEARS. Baton Rouge Community College fielded their first baseball team in 2005. The Bears appeared in the Community College World Series that year and won a doubleheader against Pearl River (Mississippi) Community College. This shot features the Bears as they celebrate their Opening Day victory in 2006. Team administrative assistant Bob Waltman beams, "There is tremendous talent along the I-10 corridor." The majority of today's team lives within a 50-mile radius of the school. (Courtesy of Bob Waltman.)

ALEX BOX THE SPORTSMAN. Simeon Alex Box was born August 5, 1920, in Quitman, Mississippi. The Cincinnati Reds were interested in Alex, but he opted for a college education. He received a football scholarship at LSU and began his studies in 1938, majoring in petroleum engineering. He played wingback his sophomore year but dislocated his shoulder in a 1939 game against Holy Cross. Undeterred Box turned to baseball and was a letterman on the 1940 and 1942 teams. In the outfield, he again dislocated his shoulder but continued to play. (Courtesy of LSU Libraries' Special Collections, Baton Rouge.)

ALEX BOX, THE HERO. LSU's baseball stadium is named after a fallen hero, Simeon Alex Box. Alex began his studies at the university a year before Germany invaded Poland. With America's entry into World War II, Second Lieutenant Box became a combat engineer. He was awarded the Distinguished Service Cross, the army's second highest decoration for heroism, when he risked his life in November 1942, single-handedly destroying six enemy machine gun nests with hand grenades. Sadly, in February 1943, 18 days after being promoted to first lieutenant, Alex was killed in a mine explosion. His body is buried in North Africa. The LSU community wished to remember their fallen comrade in a special manner. In the spring of 1943, the LSU Board of Supervisors voted to name the school's baseball facility Alex Box Stadium. (Courtesy of Earle Wagley.)

# HOMETOWN HEROES

Events during our lifetime help determine the image of a hero. Each American generation can look to specific events that refocus the word's meaning, whether through the actions of a person at Pearl Harbor or during 9/11. When folks opened their homes to flood victims following Hurricane Katrina, although they might not realize it, they too are heroes.

Mythology scholar Joseph Campbell compellingly lectured that heroes of world folklore all share the same attributes. Namely a hero's home is endangered; the hero leaves on a quest, confronts a challenge, and returns home with knowledge that saves his land. Baseball commissioner A. Bartlett Giamatti successfully equates this story with a runner's journey around the base path.

Are there baseball heroes? The word "hero" takes on a variety of shades when applied to sports. Selflessness and community outreach come to mind. The authors hope this book illustrates that baseball is still home to countless heroes. Many individuals connected with Baton Rouge are heroes of the game—some on the diamond and others off the field. There are far more people of this caliber than there are pages in this chapter. The stories here take into consideration heroics beyond just those accomplished in roaring stadiums. They include the sense of wonder that the game holds for children, as well as players overcoming injury to help their team. They include building a community ballpark. And they include those who hold onto timeless moments and share that excitement with fans.

THE BASEBALL WIZARD OF PERKINS ROAD. Born in the Perkins Road plantation country in 1888, "Johny" Burris loved baseball. Known as the "Baseball wiz of Perkins Road," he played ball in the fields where today's Lee Drive and Perkins intersect. Tales of his batting prowess have been passed down. Johny's daughter Christine (who died in 1982) always related how his mother-in-law "didn't want her daughter Pearl marrying Johny because he was a baseball player. She considered it frivolous and didn't understand why he wasn't a planter!" Burris died in 1916 of tuberculosis. (Illustration by Richmond, Virginia, artist Cheryl Garrett.)

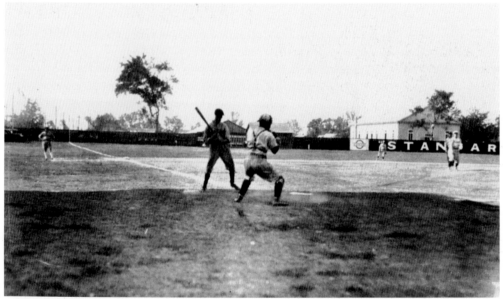

FLOOD RELIEF. The Tigers played Standard Oil in a May 12, 1927, charity game to raise money for victims of the Great Flood of 1927. The contest took place at Standard Field and raised several hundred dollars. LSU led 5-1 going into the bottom of the 9th when the Standards tied the game. With two outs in the 10th and the bases loaded, the Tiger pitcher hit Baxter Crawford, forcing in the winning run. (Courtesy of LSU Libraries' Special Collections, Baton Rouge.)

HOMETOWN HEROES

BASEBALL ACTIVIST. Tom Pete Purvis was a native of Scotlandville and pitched for the New Orleans Creoles, New Roads Stars, and Hardwood Sports. During his playing days, he worked at the Esso Refinery. Pete was actively associated with BREC (Recreation and Park Commission for the Parish of East Baton Rouge), and he started a Little League program for at-risk youth. In 2002, Nairn Drive Park on Valley Street was renamed Tom Pete Purvis Park in his honor. (Courtesy of Myrtle Keller-Perkins.)

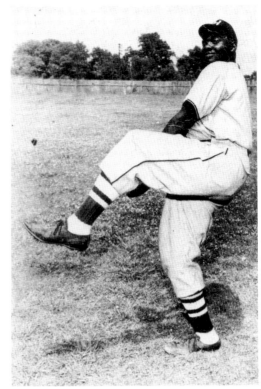

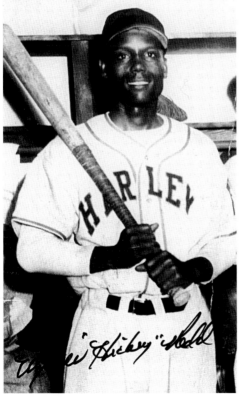

THE GOOD FIGHT. Shortstop Ulysses "Hickey" Redd was born in Baton Rouge on November 13, 1914. He played with New Orleans and Shreveport. Before being drafted into the armed forces, he was with the Birmingham Black Barons of the Negro American League from 1940 to 1941. In the late 1940s, he played summer ball in Canada and barnstormed in the fall with the Harlem Globetrotters baseball team. He ended his career with the Chicago American Giants and then was a Baton Rouge letter carrier, retiring in 1982 with over three decades of government service. (Courtesy of Robert D. Retort.)

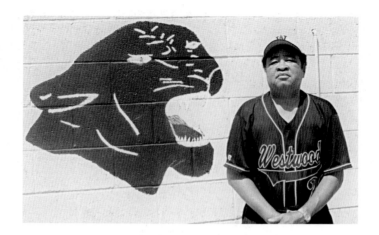

A TALE OF TWO ROYS: MCGRIFF AND CAMPANELLA. McGriff majored in history at Southern University. The freshman catcher was a member of the first Jaguar team to capture the NAIA Baseball Championship. He emulated the style of Brooklyn catcher Roy Campanella: "I'd watch the way Campy played and I approached the game the same way." Roy coached high school baseball in Florida from 1963 to 1989. McGriff is proud of all his players, especially catchers Ed Hearn and Charles Johnson, who appeared in the World Series. Roy is pictured here next to the Westwood High School Panthers' dugout. (Courtesy of Roy McGriff.)

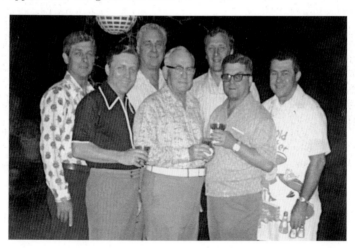

THE BASEBALL FAMILY. Few families have had as much impact on baseball as the Didier family of Baton Rouge. Minor leaguer Irby Didier's six sons all played pro ball. Pictured from left to right, Pearce played outfielder with Thibodaux and managed the semipro Homer Louisiana Oilers; Gerald signed with Brooklyn in 1952; Raymond signed with Port Arthur (he also coached LSU to their 1961 SEC championship); father Irby played with Marksville; Mel pitched with the Detroit organization (1948–1949); Clyde caught briefly for the Red Sticks; and Bob was a catcher with Greenville in 1940. (Courtesy of Bob and Joyce Didier.)

HOMETOWN HEROES

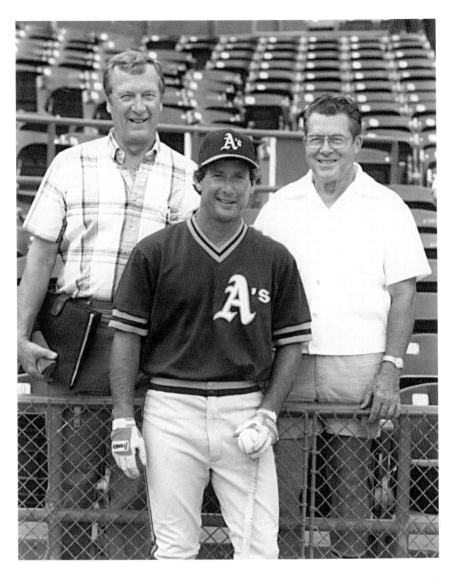

MEL THE MIRACLE MAN. Mel Didier (standing on the left) is the only person in major-league history to hold important administrative posts at the start-up of three expansion teams: the Expos in 1969, the Mariners in 1977, and the Diamondbacks in 1997. As a Dodger scout during the 1988 World Series, Mel advised the players about A's ace reliever Dennis "Eck" Eckersley. Whenever facing left-handed hitters with a 3-2 count, with the winning or tying runs at second or third, Eck always threw a backdoor slider. Injured Kurt Gibson hobbled to the plate as a pinch hitter remembering Mel's words. As Mel puts it, "Eck threw it and Gibson hit it." The two out, two run, bottom-of-the-ninth pinch homer gave Los Angeles a dramatic game one victory. A baseball man to the core, Mel Didier is named after the great Mel Ott. Mel's son, Bob "Hiya" Didier (center) played for the Atlanta Braves and later coached for the Oakland A's. Mel's brother, Bob, (right) was a manager in the A's minor league system. (Courtesy of Bob and Joyce Didier.)

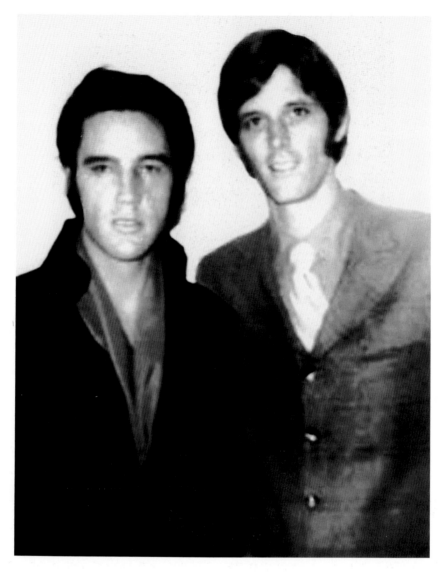

THE KING AND THE COACH. John Fred Gourrier Jr. was born in Baton Rouge on May 8, 1941. His father played minor-league ball and was a star on the semipro Esso team. John Fred Jr. joined his first band at Catholic High School and in the late 1950s, formed John Fred and the Playboys. The group performed R&B throughout southern Louisiana. In 1967, they released "Judy in Disguise (With Glasses)," which hit number one on the U.S. charts in January 1968, knocking the Beatles' "Hello Goodbye" from the top spot. The hit brought him in contact with the Beatles, Jimi Hendrix, and Elvis. John's musical career continued in the 1980s as a producer, and in 2001, he originated and began hosting WBRH-FM/KBRH-AM's popular show *The Roots of Rock 'n' Roll*. John Fred recorded "Baseball at the Box," honoring the LSU Tigers and Skip Bertman. In 1991, he was inducted into the Louisiana Music Hall of Fame, and in 1999, he received the Louisiana Music Living Legend Award. John Fred passed away in 2005. (Courtesy of Sandra Gourrier.)

TOUCHING LIVES. John Fred coached youth baseball for nearly three decades. Many boys did not realize his extensive rock-and-roll background. Sandra, John Fred's wife, explains that he "really lived two different lives. One in music and the other in baseball." Sandra declares, "But this is so true, John Fred loved baseball more than music! Music was part of his heart and soul. But John felt he touched more lives through baseball." The insert shows the 1979 Sharp Road [Park] American Legion All-Stars. From left to right are (first row) S. Roy, C. Tremont, A. Cannon, J. Barron, S. Rube, and unidentified; (second row) D. Constant, F. Divittorio, S. Arceneaux, B. Dichute, and C. Wagoner, and C. Johnson; (third row) P. Godeaux, J. Blouin, C. Richard, K. Myers, T. Badeaux, J. Lessard, S. Rube, and T. Bankston; (fourth row) Coaches: R. Payne, R. Waltman, John Fred Gourrier, and D. Faulk. In the late 1980s, John Fred began his coaching career with Catholic High School's ninth-grade team and served as head freshman baseball coach from 1995 to 2003. (Courtesy of Sandra Gourrier and Bob Waltman.)

FROM T-BALL TO OLYMPIAN. Baton Rouge–born Jason Williams's earliest sports memory is of playing T-ball when he was four years old. Here he is doffing his cap during team introductions in the bronze medal round against Nicaragua in the 1996 Summer Olympics. Team USA won 10-3. (Courtesy of Jason and Christine Williams.)

LOUISIANA MEMORIES. Major leaguer David Dellucci carries Baton Rouge baseball memories of a state championship contest in Bastrop interrupted when the mosquito truck backed onto the field to fog-out the ravenous insects. David recalls feeling butterflies in his stomach at the age of 10 while trying out for American Legion. A successful decade in the majors still produces those life-affirming Louisiana butterflies each spring training. (Left courtesy of Michael and Bernie Dellucci. Right courtesy of Topps Corporation.)

HOMETOWN HEROES